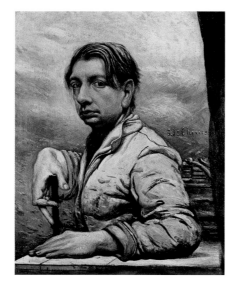

Magdalena Holzhey

GIORGIO DE CHIRICO

1888–1978

The Modern Myth

TASCHEN

COVER:
The Mystery and Melancholy of a Street (detail), 1914
Oil on canvas, 87 x 71.5 cm
Private collection

BACK COVER:
Self-portrait with Palette (detail), 1924
Tempera on canvas, 76 x 61 cm
Winterthur, Kunstmuseum Winterthur

PAGE 1:
Autoportrait, c. 1923
Oil on canvas, 74 x 62 cm
Private collection

PAGE 2:
Giorgio de Chirico, 1972
Photographed by Tony Vaccaro
© Tony Vaccaro

To stay informed about upcoming TASCHEN titles, please request
our magazine at www.taschen.com/magazine or write to TASCHEN America,
6671 Sunset Boulevard, Suite 1508, USA-Los Angeles, CA 90028, contact-us@taschen.com, Fax: +1-323-463.4442.
We will be happy to send you a free copy of our magazine which is filled with information about all of our books.

Project management: Juliane Steinbrecher, Cologne
Editing, layout and typesetting: stilistico, Cologne
Translation: Karen Williams, Rennes-le-Château, France
Cover design: Claudia Frey, Cologne
Production: Tina Ciborowius, Cologne

Printed in Singapore
ISBN 978-3-8228-4152-5

Contents

The departure of the Argonaut

"And what shall I love if not the enigma?" wrote Giorgio de Chirico in Latin beneath his first self-portrait of 1911 (ill. p. 10). The painter depicts himself in profile, his head resting in his left hand in the classic pose of the melancholic. His eye, although open, contains no recognizable pupil. The background is provided by a cloudless sky of a cold, airless green. The self-portrait arose at the start of the period of Pittura Metafisica – "Metaphysical Painting" – that would make de Chirico famous. Working in Italy around 1910, the artist began formulating a new poetic idiom that was subsequently labelled "metaphysical". Currents in 20th-century art such as Surrealism and Neue Sachlichkeit ("New Objectivity") would be decisively influenced by de Chirico's painting, which was based not predominantly upon formal innovation, but upon a new way of seeing objects and pursuing their hidden significance.

In programmatic fashion in his self-portrait, de Chirico proclaims the enigma as the stimulus and goal of his artistic search. "One must paint all the phenomena of the world as an enigma," he wrote in around 1913. It is this mysterious strangeness of things in de Chirico's paintings, with their mood of profound loneliness and melancholy, which is so immediately striking. The world that confronts us in the works by this Italian master is a world of shadow and illusion, of cold green skies, of airless spaces and nonsensical perspective. In his paintings, objects cease to be unambiguous.

De Chirico paints recognizable objects, but he combines them in such a way that familiar and everyday things – a girl bowling a hoop, an open carriage, a train, a glove, a tower – become strange, secretive, apparently meaningless objects. In an early text he wrote: "To become truly immortal, a work of art must escape all human limits: logic and common sense will only interfere. But once these barriers are broken, it will enter the regions of childhood vision and dream." De Chirico was the first artist of the modern era to recognize and translate the ambiguity of the visible world. With his Pittura Metafisica he created what the Surrealist writer André Breton would later call the "modern myth": pictures of a new melancholy, which lend pictorial expression to the loss of meaning and sense of alienation experienced by modern man.

The poetics of Metaphysical painting was nourished by a complex interweaving of personal and collective memory, associative and rational stimuli, inspiration – de Chirico speaks of "revelation" – and an intensive reading of

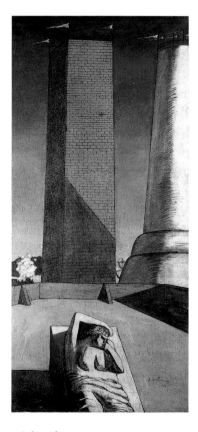

Ariadnes Afternoon, 1913
Oil on canvas, 134.5 x 65 cm
Private collection

The Dying Centaur, 1909
Oil on canvas, 118 x 75 cm
Rome, Collezione Assitalia

philosophy. De Chirico was influenced above all by the writings of Friedrich Nietzsche: the pose he strikes in his self-portrait of 1911 (ill. p. 10) is a direct citation of Nietzsche's own portrait photograph (ill. p. 11). De Chirico saw Nietzsche not only as a guiding light but also as a figure of identification: he felt they shared a similar nature and were in a fateful way linked – it was in 1888, after all, the year of de Chirico's birth, that Nietzsche's career came to a desperate climax in Turin, before he collapsed in the street in the first few days of January 1889 and lost his sanity for good.

With Nietzsche, de Chirico shared not only his love of the enigma but also his fascination with the world of classical mythology. Both the Latin quotation beneath the programmatic self-portrait and the eye devoid of a pupil make reference to the blind seer of antiquity. We will encounter the notion of outer blindness again and again in de Chirico's œuvre. Blind to the present, the eye is not fixed on outward form but sees the inner or future shape of things. The Metaphysical artist therefore assumes a prophetic ability to turn his gaze upon the unfamiliar aspect of things.

De Chirico's sensitivity and his melancholic nature, so extremely receptive to mood, caused him to develop intense relationships with many places and ex-

The Departure of the Argonauts, 1909
Oil on canvas, 73 x 92 cm
Private collection

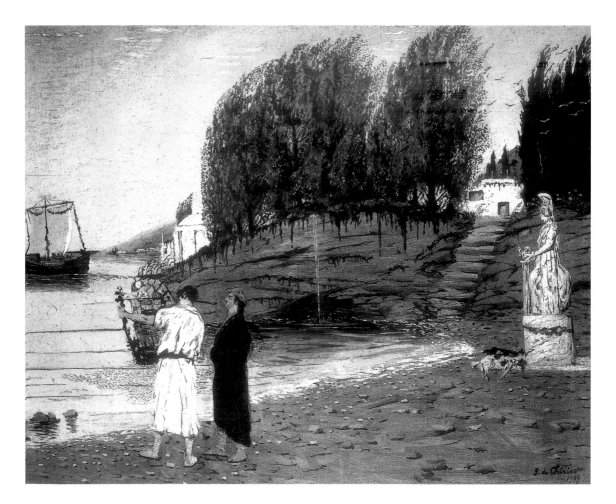

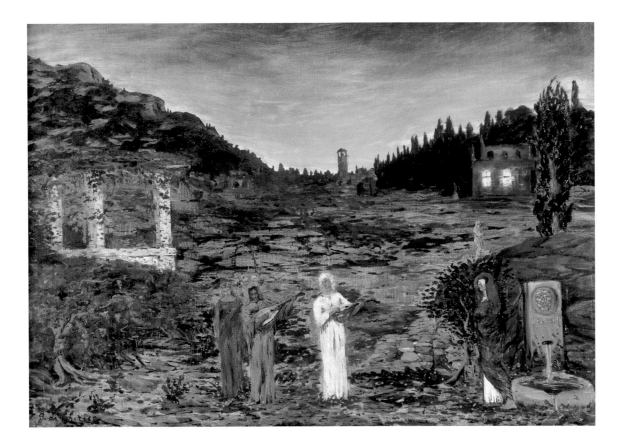

Serenade, 1909
Oil on canvas, 82 x 120 cm
Berlin, Staatliche Museen zu Berlin –
Preußischer Kulturbesitz, Nationalgalerie

periences. His birth in Greece, on the periphery of modern Europe, was something he always considered fateful. Giorgio de Chirico was born on 10 July 1888 in the Thessalian port of Volos, as the eldest son of Gemma and Evaristo de Chirico. In 1891 a second son was born, Andrea Alberto, who as an artist would later use the name Alberto Savinio. The brothers liked to say their parents were of direct Italian origin, but in fact the de Chirico family had lived in the Levant for generations. Evaristo was an engineer and founded a successful company that was contracted to build Thessaly's railway network following its cession to Greece in 1881. The nature of Evaristo's job meant that the family moved several times during the course of Giorgio's childhood, before settling permanently in Athens in 1897.

All his life, de Chirico attached great importance to his "mythic" origin from classical Greece, the centre of the ancient world. His birth in Volos, the site from which, in Greek legend, Jason and the Argonauts set sail on their quest to find the Golden Fleece, repeatedly served de Chirico as a means of mythicizing his own personal history. In an autobiographical sketch he talks about himself in the third person: "Thus he spent the early years of his youth in the land of classicism; he played along the shores that watched the Argonauts' ship put out to sea, and at the foot of the mountain that witnessed the childhood of the fleet-footed Achilles and the wise admonitions of his teacher, the centaur." This identification with the heroes of Greek saga lent de Chirico's own life a mythic dimension and a certain timeless validity. In a similar fashion, childhood

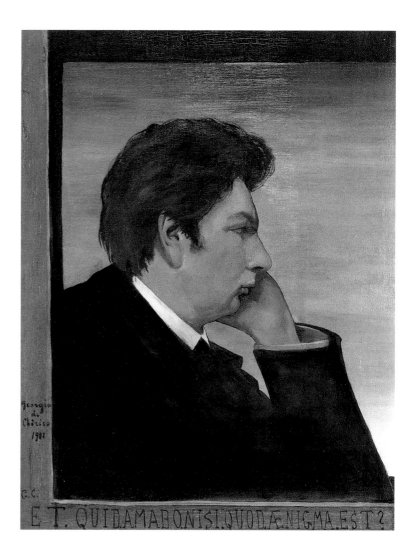

**Self-portrait (Et quid amabo
nisi quod aenigma est?),** 1911
Oil on canvas, 72.5 x 55 cm
Private collection

"And what shall I love if not the enigma?"

memories of early travels and his father's job are later processed and refined in
de Chirico's paintings into poetic images of trains on the horizon – metaphors
for the passage through life and along an artistic path, the departure for new
shores and the journey into the unknown.

In Athens the de Chirico brothers were educated by a succession of private
tutors, who taught them Italian, French and German, amongst other subjects.
While Alberto began studying music, Giorgio took drawing lessons and around
1900 entered the Athens Polytechnic, where over the next six years he received
a solid grounding in art. In May 1905 his father died unexpectedly. Gemma
decided to move with her two gifted sons to Munich; Greece had enjoyed close
cultural ties with Bavaria in the 19th century and consequently most graduates
from the Polytechnic went on to study in Munich. The family left Athens in
September 1906 and travelled to Munich via Italy. At the end of October, having
passed the entrance examination, "Georg von Kiriko" was admitted to the Royal
Academy of Fine Arts and took classes in drawing and painting with Gabriel
von Hackl and Carl von Marr. Alberto, meanwhile, studied harmony and coun-

terpoint with the famous composer Max Reger. Giorgio, who spoke German considerably better than his brother, had to accompany him to these lessons as a translator. It was in this way, de Chirico later recorded, that he first encountered the works of the Basle artist Arnold Böcklin. Reger owned an album of large photogravures of paintings by Böcklin, which de Chirico would leaf through while his brother was having his music lesson. No other artist, with the exception of Max Klinger, would exert such a potent influence upon de Chirico's development as Arnold Böcklin. It is a sign of de Chirico's independence of mind that he embraced Böcklin as his model just as the art historian Julius Meier-Graefe, in his influential book *Der Fall Böcklin* ("The Case of Böcklin") of 1905, was criticizing the late Romantic painter as antiquated and out of date. De Chirico, on the other hand, recognized in Böcklin's mythical landscapes, as also in the often surreal atmosphere of Max Klinger's graphic works, the unique ability to combine the world of legend with modern life, the supernatural with the everyday, in a matter-of-course fashion.

Böcklin's influence only made itself apparent in de Chirico's œuvre from autumn 1908, however, after he had left the Munich Academy. The mysterious *Dying Centaur* (ill. p. 6) of early 1909 is a mixture of elements from Böcklin and Klinger. Over the winter of 1908/9 de Chirico passed many hours in the company of his Munich friends, visiting museums and printrooms in order to study etchings by Klinger, which fascinated him with their enigmatic combination of elements, autobiographical and imaginary, quotidian and mythical, real and unreal.

The developments taking place in de Chirico's painting also followed an extended visit, in the summer of 1908, to Milan, where his mother and brother were now living; Giorgio would join them permanently in early summer 1909. Dating from this period are the first works to deploy the technique subsequently so central to Pittura Metafisica, namely the combination of autobiographical and mythological elements. In *The Departure of the Argonauts* of 1909 (ill. p. 8), for example, the composition takes as its starting-point the legend of Jason and the Argonauts, who – to the strains of Orpheus on the lyre – set sail from the port of Volos on their quest to find the Golden Fleece. For the first time in his portrayal of a mythological subject, however, we now find de Chirico incorporating elements drawn from personal memory. The Argonauts' quest was more than a mere metaphor for the artistic journeys of the two brothers, born on the same Greek shores; on the right-hand edge of the canvas, on a plinth surrounded by sacrifices and offerings for a successful voyage, the statue of the goddess Athena cites almost exactly the monument erected in front of the railway station in Volos built by Evaristo de Chirico.

The world of myth, the earliest tales of humankind, is fatefully bound up with the story of the artist, who creates it anew. In his poetic writings from the years 1911 to 1915, de Chirico repeatedly invokes the ability of the artist to transport himself back to a state corresponding to that of the sage at the beginning of time. With the aid of philosophical, prophetic and visionary gifts, the world can be interpreted, myths created, hidden truths revealed: "One of the strangest and deepest sensations that prehistory has left us with is the sensation of presentiment. It will always exist. It is like an eternal proof of the senselessness of the universe. The first man must have seen auguries everywhere, he must have trembled at each step he took."

The development of de Chirico's Metaphysical imagery was fuelled above all, as observed earlier, by his reading of Friedrich Nietzsche, the German phil-

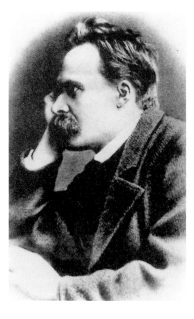

Portrait photograph of Friedrich Nietzsche, 1882

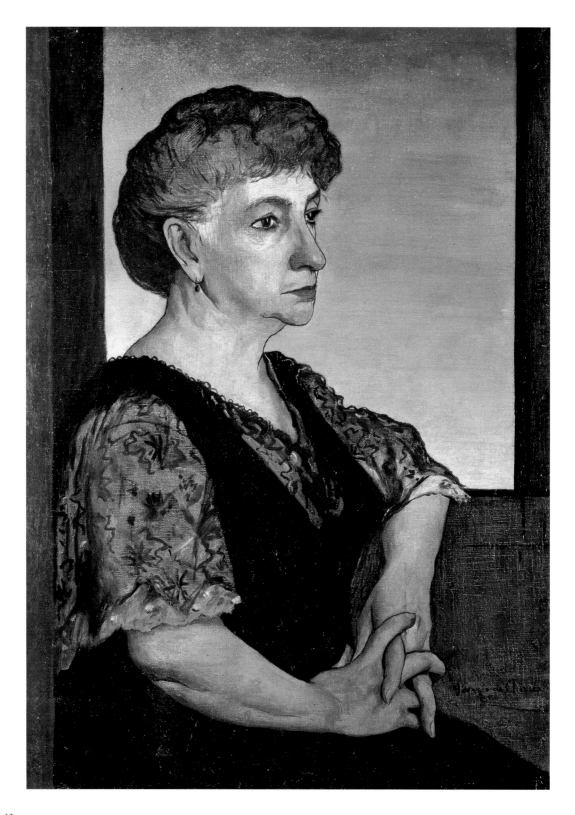

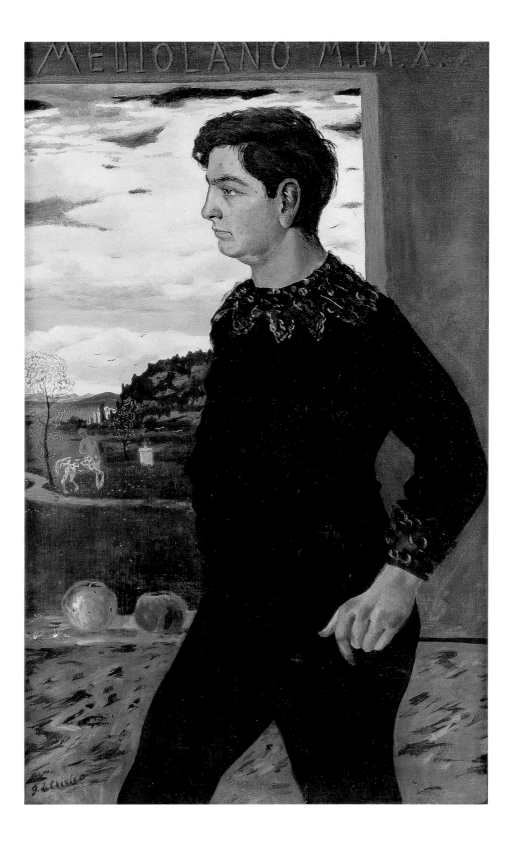

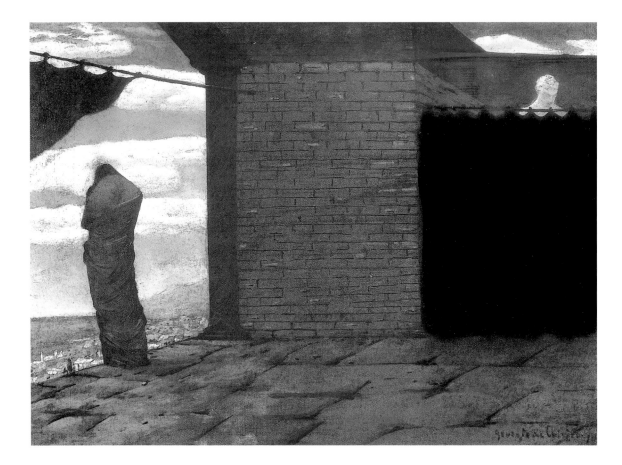

The Enigma of the Oracle, 1910
Oil on canvas, 42 x 61 cm
Private collection

The contemplative figure seen in rear view
is cited almost literally from Böcklin's *Ulysses
and Calypso* (ill. p. 15). It here becomes the
artist-philosopher who stands pensively before
the mysteries of the world. In the background,
the oracle concealed behind the curtain alludes
to the enigmatic, hidden dimensions of existence.

osopher who died in 1900. De Chirico would undoubtedly have encountered
some of Nietzsche's ideas during his time as a student in Munich, but it was
only in Milan that he immersed himself in some of Nietzsche's most important
writings, including *Ecce Homo* and *Thus Spoke Zarathustra*. These produced a
radical change in the artist's work. What fascinated de Chirico first of all about
Nietzsche was his powerfully poetic style of writing, his ability, through his use
of language, to make objects appear in a new and unexpected light. Thus the
closing verses of Zarathustra's *Drunken Song* run: "O man! Take heed! What
saith deep midnight's voice indeed? 'I slept my sleep–, From deepest dream I've
woke, and plead:– The world is deep, And deeper than the day could read. Deep
is its woe–, Joy – deeper still than grief can be: Woe saith: Hence! Go! But joys
all want eternity–, –Want deep, profound eternity!'"

De Chirico loved these lines by Nietzsche above all others and could quote
them even as an old man. In 1910 he wrote to his Munich student friend Fritz
Gartz: "Do you know, for example, who is the most profound painter who ever
walked this earth? … I tell you he is Arnold Böcklin; he is the only man who
has painted profound paintings. Do you know who is the most profound of
all poets? … the most profound of all poets is called Friedrich Nietzsche …
Profundity, as Nietzsche and I myself understand it, is not to be found where
it has hitherto been sought. My paintings are small, but each one is an
enigma."

It is this love of enigma that provides the common ground between the philosopher and the painter and their respective views of the world. In both cases it was fired by a study of the Greek philosophers, and above all the pre-Socratic Heraclitus, who started from a belief in a Nature, who is animated by mysterious forces and whose meaning is only revealed – like the wisdom of the oracle – in signs.

The Enigma of the Oracle (ill. p. 14) already points to the new direction taken by de Chirico's work as from autumn 1909. Its format is considerably smaller than earlier works; the palette is different and the composition and brushstroke simplified. Although de Chirico is by now freeing himself from Böcklin's style, he once again borrows one of his predecessor's poetically charged motifs. Thus the pensive figure wrapped in a long cloak seen in rear view, fully in the Romantic tradition of contemplative figures seen from behind, is cited almost literally from Böcklin's *Ulysses and Calypso* (ill. p. 15) of 1882. De Chirico was fascinated during this period by Homer's account of the wanderings of the Greek hero Odysseus, who, as the embodiment of a traveller with an uncertain destiny, became another figure of identification in his own life story. Böcklin's pensive Ulysses, yearning for home, becomes in de Chirico's painting a thinker contemplating the enigmas of the world and the mystery of his own existence. The oracle, voice of fate, is present in the shape of the marble head of a statue concealed behind a curtain.

De Chirico also adhered to Nietzsche in his understanding of a "metaphysical" art. Nietzsche's use of the word metaphysics was thoroughly ambiguous. It was a term he employed frequently, and he even described art as the "true metaphysical activity of life". At the same time, however, he spoke with contempt of "backworldsmen" who believed that the meaning of things and all profound sensations could only be found in a metaphysical realm, a "backworld" of whatever shape or form. His aim was to lend the concept of metaphysics a new meaning. Metaphysics in the conventional understanding meant the investigation of questions relating to the world beyond, the divine, the ideal and ultimate reality. Nietzsche's pivotal proclamation of the "death of God", however, makes it necessary to view earthly phenomena, the products of human logic and the insistence upon the existence of an ultimate truth in relative terms: the ultimate truth sought by mankind for so long is in fact the recognition that there is no one truth at all. Any metaphysical, enigmatic and profound experiences we may have are all rooted exclusively in the present world.

It was this all-important conclusion that de Chirico took from Nietzsche. Pittura Metafisica sought the enigmatic quality of earthly phenomena not in some other dimension, but within the things of this world: "We Metaphysicians have sanctified the real," he wrote in 1919. De Chirico, with great penetration, recognized this aspect in Nietzsche, who did not limit himself to the destruction of an idealistic truth but prepared the ground for a new poetics: "Schopenhauer and Nietzsche taught first and foremost the profound significance of the nonsense of life and how such non-sense can be translated into art."

Still steeped in his reading of Nietzsche, in October 1909 de Chirico took a trip to Rome and Florence. Here, as he wrote in an early manuscript, he recognized "that there is a host of strange, unknown and solitary things that can be translated into painting … What is required above all is a pronounced sensitivity." In Rome, it was the architectural element of the arcade, and the atmosphere it conveyed, that made the greatest impression upon him: "The Roman arcade is fate," he wrote, "its voice speaks in riddles which are filled with a peculiarly

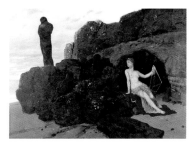

Arnold Böcklin
Ulysses and Calypso, 1882
Oil on wood, 104 x 150 cm
Basle, Kunstmuseum Basel

The Enigma of an Autumn Afternoon, c. 1910
Oil on canvas, 45 x 60 cm
Private collection

De Chirico's first Metaphysical painting arose
after the famous "revelation" that he experi-
enced in Piazza Santa Croce in Florence. Reality
is transformed into a disconcerting composition
that conveys a profoundly enigmatic atmosphere.
The dating of this picture remains the subject of
debate amongst art historians.

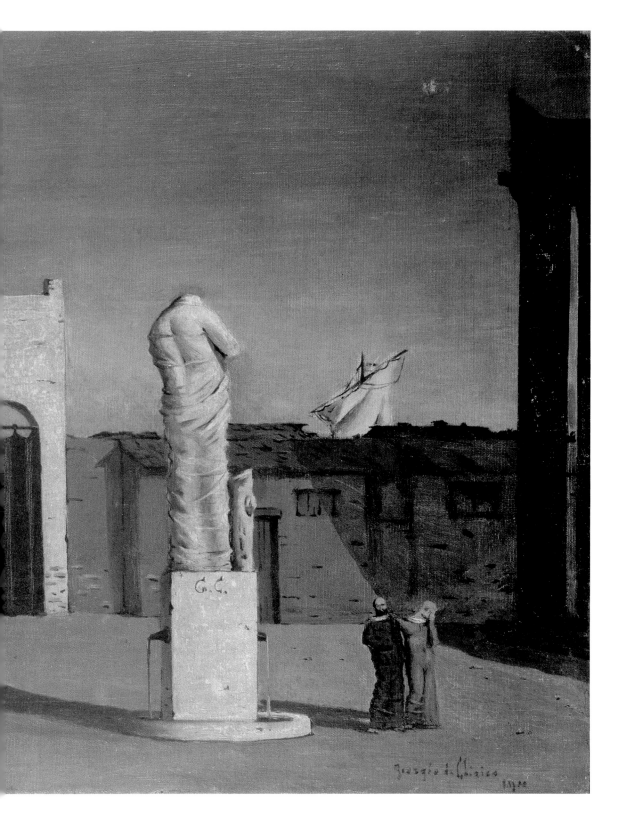

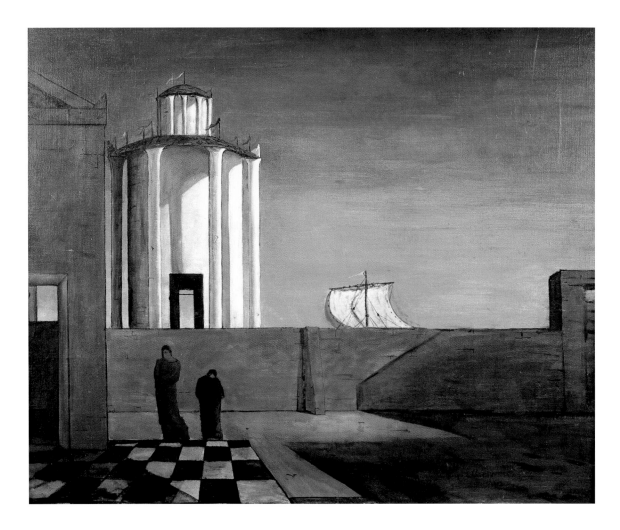

The Enigma of the Arrival and the Afternoon,
1911/12
Oil on canvas, 70 x 86.5 cm
Private collection

Roman poetry." These Roman arcades, whose nature de Chirico could already observe in the Italianate architecture of Munich's Hofgarten (cf. ill. p. 33), would become a determining feature of the settings for his Metaphysical compositions. Here, for the first time, appears the idea of a Metaphysical aesthetic that is founded upon the *experience* of architecture. What is important is not what the architecture looks like, but the way it is felt – a conviction that finds its echo in the empty squares and receding depths, shadowy arcades and soaring towers of de Chirico's works from 1911 onwards.

On his way back to Milan from Rome, de Chirico stopped off in Florence. His brief visit proved a turning point on his artistic path. In many of his writings, the painter describes the innovations and changes in his work as "revelations" born of the sudden experiencing of something new. Drawing support from his study of Friedrich Nietzsche and Arthur Schopenhauer, de Chirico frequently reflected upon the nature of such moments of inspiration, in which an unfamiliar aspect of the world suddenly reveals itself. He recorded the first of his own such revelations in a now famous passage: "One clear autumnal afternoon I was sitting on a bench in the middle of Piazza Santa Croce in Florence.

It was of course not the first time I had seen this square. I had just come out of a long and painful intestinal illness, and I was in a near morbid state of sensitivity. The whole world, down to the marble of the buildings and the fountains, seemed to me to be convalescent … The autumn sun, cold and unloving, lit the statue and the church façade. Then I had the strange impression that I was looking at all these things for the first time, and the composition of my picture came to my mind's eye … Nevertheless the moment is an enigma to me, for it is inexplicable." This moment of intuition, barely explicable in rational terms, this experience of a rupture between reality and sensation, provided the genesis of *The Enigma of an Autumn Afternoon* (ill. p. 16/17). If we compare the painting with a photograph of Piazza Santa Croce, we can see how the actual architecture of the square metamorphoses in de Chirico's canvas into a disconcerting composition of figures and signs. The pediment of the Renaissance church has been transformed into a Greek temple. The monument to Dante in the centre of the square becomes an antique statue seen from behind in the pose of the introspective thinker. Behind the reddish wall of the cloister beside the church of Santa Croce appears the sail of a passing ship.

The Enigma of an Autumn Afternoon is the first painting assigned to the Pittura Metafisica group of works in de Chirico's œuvre – a picture based on

The Enigma of the Hour, 1910/11
Oil on canvas, 55 x 71 cm
Private collection

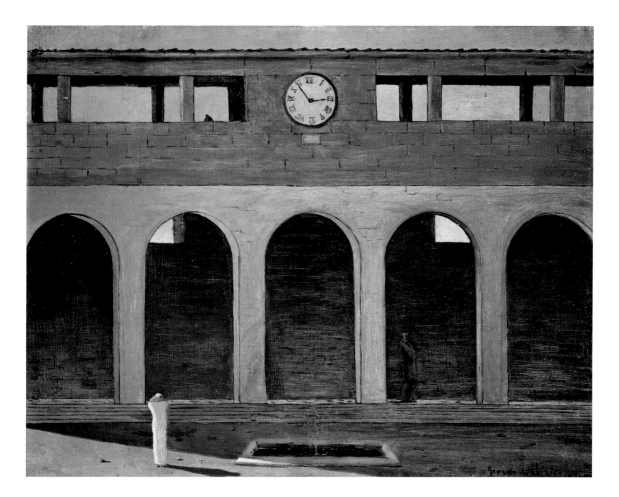

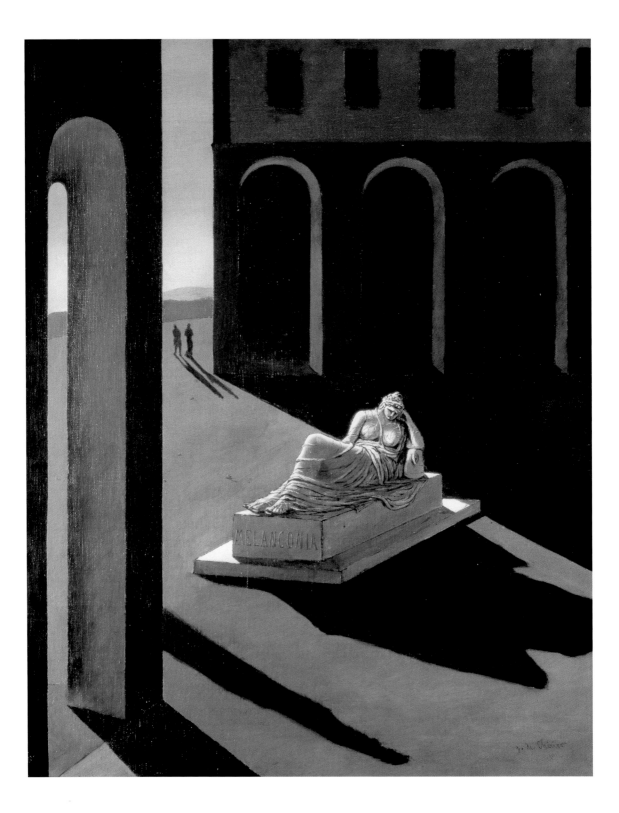

actual perception that shifts the things of reality into the realm of the inexplicable. For the first time, de Chirico entirely renounces elements that follow a narrative logic and creates a picture sustained solely by its disconcerting atmosphere.

The artist continued to develop his newly discovered pictorial language in the paintings that immediately followed. The wall dividing the pictorial space horizontally in half, for example, also determines the composition of *The Enigma of the Arrival and the Afternoon* (ill. p. 18). Here, too, the wall serves to separate the realm of the visible from that of the invisible and mysterious – once again indicated by a ship's mast and sail, which may be understood as symbols of the departure of the artist and of the search for unknown shores. Making their first appearance in this painting are two devices that will subsequently become firm components of de Chirico's Metaphysical language. One is the deployment of multiple perspectives – in this painting we can identify four different vanishing points – and the other is the tower-like building that rises from an indeterminate area behind the wall. Precisely because it lacks a firm anchoring, this edifice underlines the contrast between the realms of the known and unknown, the finite and infinite. The pictorial space is still divided horizontally into two strictly separate planes and does not yet open up into the Metaphysical piazzas with their dislocated perspective depth. De Chirico was nevertheless aware that he had discovered the foundations of a new language. In January 1911 he wrote excitedly – and in a thoroughly Nietzschean vein – to his friend Fritz Gartz: "… a new sort of air has flooded my soul. I have heard a new song, and the whole world now seems completely transformed to me. The autumn afternoon has arrived with its long shadows, clear air and cloudless skies. In a word, Zarathustra has arrived. Do you understand?"

"She loves her strange soul. She has vanquished. And now the sun has come to a halt high above in the middle of the sky; and the statue, in eternal happiness, immerses her soul in the contemplation of her shadow."

Giorgio de Chirico

Solitude (Melancholy), 1912
Oil on canvas, 79 x 63.5 cm
London, Eric and Salome Estorick Foundation

The loneliness of modern man

In 1911 the de Chirico family moved to Paris, and on the way stopped for two days in Turin. On his mother's advice, Giorgio had previously attended a military medical examination and had been declared fit for service; when he received his draft papers in October 1911, however, he ignored them. In March 1912 de Chirico was once again commanded to present himself for military duty – this time in Turin, which lay closest to the French border. De Chirico spent ten days as a soldier before deserting; he was sentenced in his absence to a prison term that he would never have to complete, however.

His impressions of Turin, however brief his two stays may have been, were of profound significance for the development of his art. De Chirico later recorded: "It was Turin that inspired the entire series of paintings I created between 1912 and 1915. I must confess that they also owe much to Friedrich Nietzsche." That de Chirico decided to obey his call-up orders at all was undoubtedly due to his given posting: the artist, who always believed in signs and predetermined acts of providence, saw the hand of fate in the fact that he was to be stationed in the very city that Nietzsche had loved so much and where he spent his last, highly productive year with his mind at its most lucid. It was here that the philosopher wrote *Ecce homo* and *The Case of Wagner*, and it was from here, after descending into madness, that he sent letters to his friends in which he identified himself variously with the god Dionysus, the Savoy kings Carlo Alberto and Victor Emmanuel II, and with Alessandro Antonelli, architect of the Mole Antonelliana (cf. ill. p. 31) in Turin.

Nietzsche's letters from this period, and his book *Ecce homo* in particular, are full of imagery inspired by the singular atmosphere of Turin. Nietzsche describes the mood of autumnal afternoons, the spacious squares of the Baroque city centre bordered by their shady arcades, and the long, straight avenues which go back to the rectilinear layout of Roman town planning and which, on clear days, offer a view all the way to the mountains on the horizon. De Chirico sought to express Nietzsche's meaning in words which simultaneously seem to describe his own pictorial world: "This new quality is a strange and profound poetry, endlessly enigmatic and incomparable, which is evoked by the atmosphere of an autumn afternoon, when the skies are clear and the shadows grow longer than in summer as the sun starts to lose height … the Italian city *par excellence* in which this extraordinary phenomenon occurs is

Metaphysical Still-life, 1914
Oil on canvas, 81.3 x 54.6 cm
New York, The Metropolitan Museum of Art,
The Alex Hillman Family Foundation

De Chirico takes up the thoughts set out by Friedrich Nietzsche in *The Gay Science*. The new, "dancing" art, whose birth is symbolized by the egg, is quickened by "the delight in an 'X'", the love of the enigma. Man should allow his thoughts to wander "light-footed" in order to interpret the mysterious metaphors and signs of the world.

I'll Be There … The Glass Dog, 1914
Oil on canvas, 69 x 57.5 cm
Private collection

Turin." Nietzsche's style of writing, so richly laden with mysterious metaphors, provided the basis for the aesthetics and iconography that de Chirico would go on to develop in probably his most famous series of works, the *Piazze d'Italia* paintings executed immediately after his stay in Turin.

The first work to exhibit the typical characteristics of these "Italian Squares" with their enigmatic mood is *The Delights of the Poet* (ill. p. 24): a wide, empty piazza bordered by shadowy arcades leading back into the depths; a high horizon with a locomotive travelling across it; a railway station; a sky of vibrant green; long, slanting shadows; in the square, a solitary figure sunk in thought. The motif of the fountain, already familiar from earlier compositions such as *The Enigma of the Hour* (ill. p. 19), is borrowed from Nietzsche. According to Zarathustra's *Night Song*: "Tis night: now do all gushing fountains speak louder. And my soul also is a gushing fountain."

Despite the sense of solitude and despite the mysterious shadow cast by an unknown source on the right, the picture retains an atmosphere of untroubled

The Delights of the Poet, 1912
Oil on canvas, 69.5 x 86.3 cm
Private collection

"There are many more enigmas in the shadow of a man who walks in the sun than in all the religions past, present and future."
Giorgio de Chirico

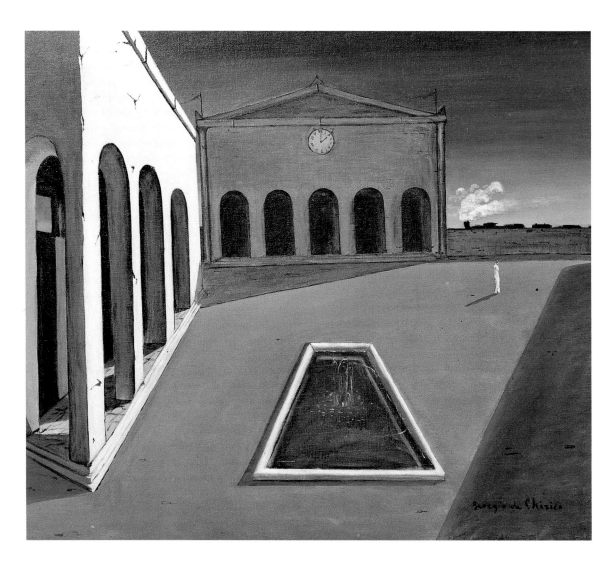

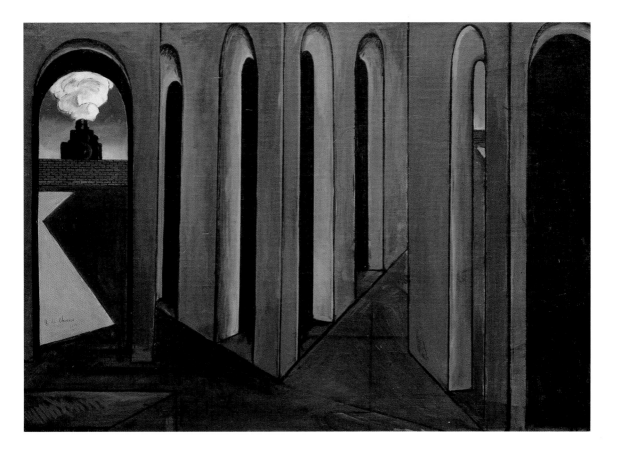

The Anxious Journey, 1913
Oil on canvas, 74.3 x 106.7 cm
New York, The Museum of Modern Art,
Acquired through the Lillie P. Bliss Bequest,
86.1950

serenity, a feeling that de Chirico associates in a fragment of lyric prose of
around the same period with the railway station, which he calls a "divine toy".

The train crossing the horizon, a motif that will appear with such frequency
from now on, combines autobiography with symbolism in a fashion typical
of Metaphysical poetics. Childhood memories – his father's job, the frequent
travelling, the railway tracks that ran directly behind the garden wall of his
parents' house in Volos – here converge with experiences from later life, such
as his memorable visit to Turin. As a symbol, the railway stands for life's jour-
ney in general and in particular for the artist's voyage into the new and un-
known. The setting sail of the Argonauts on their quest to find the Golden
Fleece, a mythic departure bound up with de Chirico's biography from the
very beginning, finds its modern formulation in the train on the horizon. In
the *Piazze d'Italia* paintings, this journey becomes increasingly oppressive,
overladen with anxieties that reflect de Chirico's precipitous flight from Turin.
In *The Anxious Journey* (ill. p. 25), the fractured sense of space and depth creates
the impression of a gloomy labyrinth. The shadowy porticoes offer no means
of exit, while a waiting locomotive rears threateningly on the horizon.

De Chirico's "Italian Squares" are infused with an unsettling, melancholy
atmosphere. They sometimes contain female statues, sculptures of the sleeping
Ariadne, borrowed from classical antiquity. In the famous work *Solitude
(Melancholy)* (ill. p. 20), a female figure in flowing draperies reclines in the

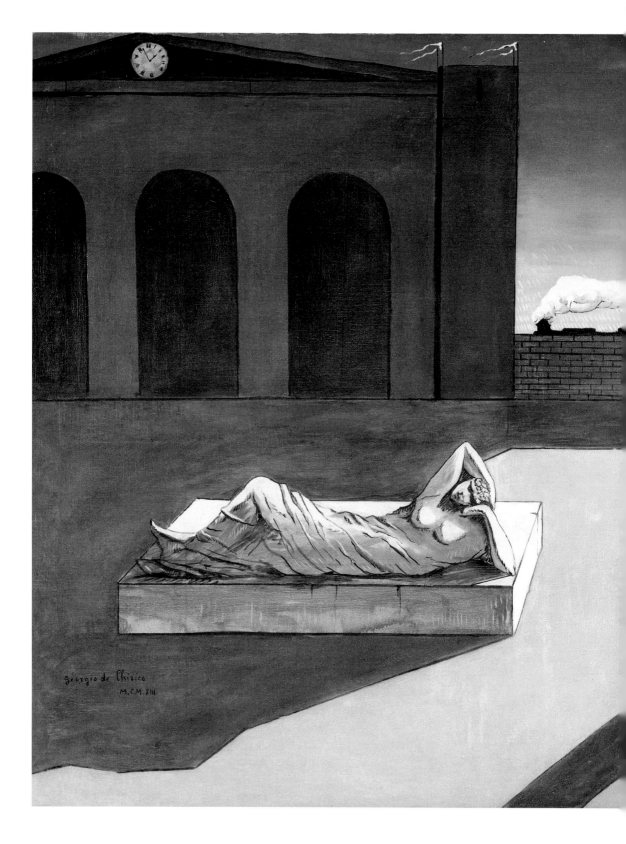

The Soothsayer's Recompense, 1913
Oil on canvas, 135.5 x 180.5 cm
Philadelphia, PA, Philadelphia Museum of Art,
The Louise and Walter Arensberg Collection

Only at first sight does the composition appear
to obey the traditional rules of linear perspective.
De Chirico's spaces, as he portrays them, cannot
exist: multiple vanishing points are combined
with shadows that have a life of their own and
times of day that are mutually contradictory.

centre of a piazza between two buildings with arcades. Engraved on the plinth of the statue is the word "Melanconia". The windows on the first floor are tightly shuttered. In the distance, we see a landscape of gently rolling hills – another detail inspired by the countryside around Turin and the descriptions of Nietzsche. The reference to Melancholy as the expression of sadness, loss and alienation from the real world finds concrete correlation in the shutters, which are closed as on the occasion of a bereavement – something the two de Chirico brothers associated with the memory of their father's early death. The scene appears to be frozen. The human figures in the background serve only to reinforce the sense of solitude. The exaggerated difference in scale between the two diminutive figures and the towering buildings heightens the unreal, stage-set character of the architecture, which is not made for people, behind which no one lives, and which appears foreign and inexplicable: "De Chirico shows the loneliness of modern man in a world estranged from him." (Wieland Schmied)

De Chirico developed the theme of the sleeping Ariadne in a series of paintings (cf. ills. pp. 7, 20, 26/27 and 29) that are once again based on his reading of Nietzsche. Ariadne was the daughter of King Minos of Crete, who kept the Minotaur, a monster who was half man, half bull, imprisoned in a labyrinth. With the aid of a long ball of thread, Ariadne enabled her lover Theseus to find his way out of the labyrinth after he had slain the monster. Together they fled to the island of Naxos, where Theseus abandoned his beloved while she was sleeping because, so the legend goes, she was intended for Dionysus, the earthly god, the god of intoxication, physical love and the mysteries of life. In Nietzsche's interpretation of the myth, the figure of Ariadne represents the female principle of art, intuitive knowing. Her awakening by the god Dionysus comes to symbolize a return to the labyrinth, whose mysteries are faced without fear by the bold thinker, and is thus a metaphor for an artistic process that unveils the unfamiliar, "metaphysical" side of reality.

De Chirico invariably depicts Ariadne asleep, abandoned by her lover and awaiting her mystical awakening by the god Dionysus, whose creative power is frequently translated into the painting in symbolic form as a chimneystack or a tower (cf. ills. pp. 7 and 29).

The motif of Ariadne also furnished de Chirico with a symbol that can be read as key to the style and composition of his paintings: his pictures lend visual form to the notion of a return to the labyrinth and of a confrontation with the mysteries of the world. His *Piazze d'Italia* are themselves no less than labyrinths, within which perspective systems are multiplied and the laws of nature contradict each other. These are pictures whose spaces cannot possibly exist in the way they appear to and where different places and times co-exist in apparent harmony.

Only at first sight does *The Soothsayer's Recompense* (ill. p. 26/27), for example, appear to obey the traditional rules of linear perspective. On closer inspection, the harmony reveals itself as deceptive; conventional means of orientation are employed in contradictory fashion. Objects and their shadows only partially correspond. The arch on the right-hand side of the piazza seems insubstantial, like a piece of cardboard scenery. The statue and the railway station in the background are seen from different angles, the statue from above right and the building frontally. The slender, multicoloured pennants are fluttering leftwards in the wind, while the smoke from the engine drifts in the opposite direction. The hands of the clock point to shortly before 2 o'clock

in the afternoon, whereas the elongated shadows are those cast by an evening sun already low in the sky.

The Turin that de Chirico, as it were, saw through Nietzsche's eyes and experienced through his emotions made its way into many of his paintings. One example is *The Red Tower* of 1913 (ill. p. 33) – the first of de Chirico's pictures, moreover, to find a buyer. The equestrian statue whose silhouette, darkly menacing and strangely alive, emerges from behind the arcade is an adaptation of the monument to the Savoy prince Carlo Alberto, which Nietzsche could see every day from the window of his Turin apartment. The motif of the massive tower rising above the horizon is also inspired in large part by Nietzsche's Turin. The philosopher particularly loved the Mole Antonelliana (ill. p. 31), which he described as "perhaps the most ingenious edifice ever constructed … I have baptized it *Ecce homo* and I have set it, in my mind, within an immense open space." The highly unusual tower-like building, whose outer form gives no clues to its possible function, was erected in the 19th century as a synagogue and is today home to a film museum. Over 160 metres high, the Mole Antonelliana is not only a distinctive feature of the Turin skyline but also the tallest masonry structure in Italy. A hall on a square ground plan is topped by an almost dizzyingly tapered cupola, surmounted in turn by a two-storey lantern in classicist style that gives way to an extremely tall spire. De Chirico had already referenced

Ariadne, 1913
Oil and graphite on canvas, 135.6 x 180.5 cm
New York, The Metropolitan Museum of Art,
Bequest of Florene M. Schoenborn, 1995,
1996.403.10

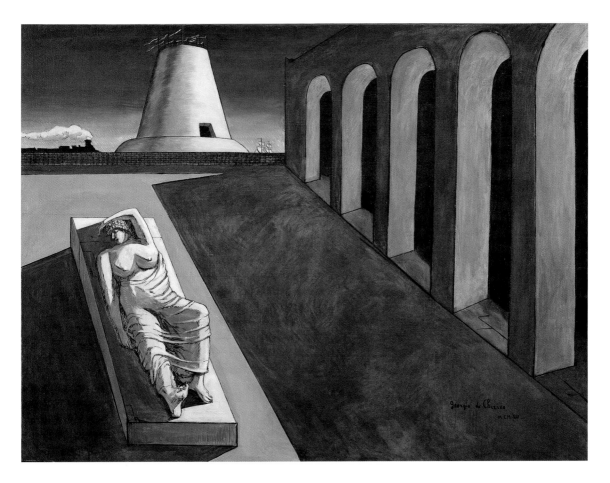

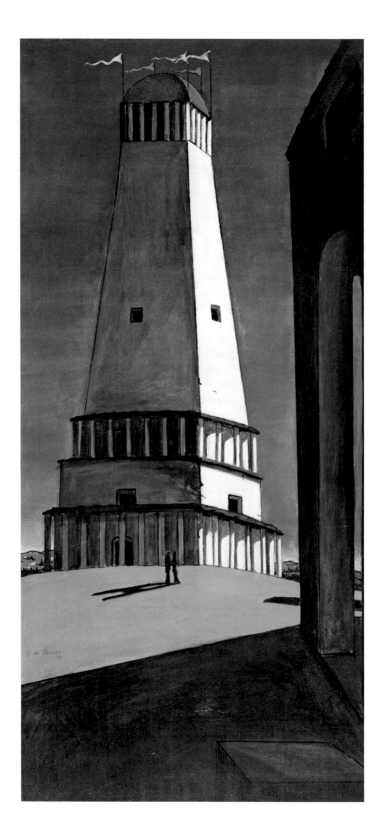

The Great Tower, 1913
Oil on canvas, 123.5 x 52.5 cm
Düsseldorf, K20, Kunstsammlung Nordrhein-
Westfalen

"Shadows cast their geometric enigma across the
piazzas. Above the walls rise nonsensical towers
topped with small, colourful flags. Everywhere
infinity, everywhere mystery. The depth of the
celestial vault makes one feel dizzy to look at it.
One shudders, one feels pulled into the abyss."
 Giorgio de Chirico

PAGE 30:
The Nostalgia of the Infinite, 1912
Oil on canvas, 135.2 x 64.8 cm
New York, The Museum of Modern Art,
Purchase 87.1936

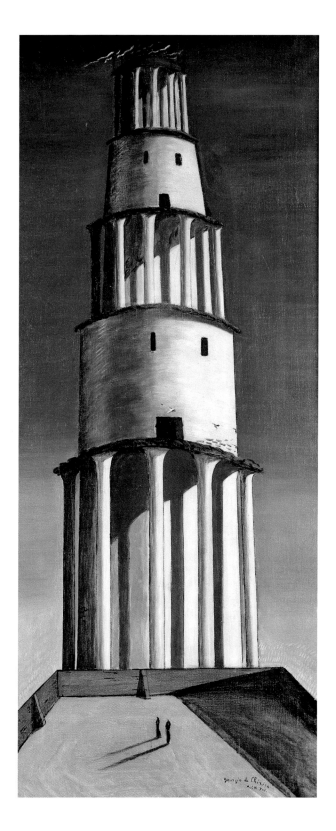

Photograph of the Mole Antonelliana in Turin

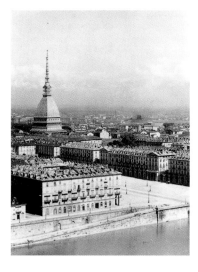

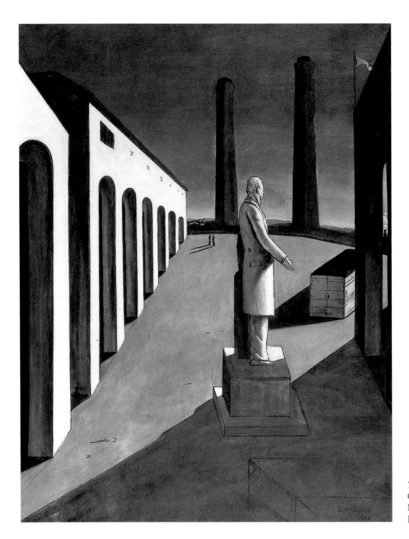

The Enigma of a Day (I), 1914
Oil on canvas, 185.5 x 139.7 cm
New York, The Museum of Modern Art,
James Thrall Soby Bequest, 1211.1979

the architecture of the Mole Antonelliana in *The Nostalgia of the Infinite* (ill. p.30):
by siting the tower on the crest of a hill, de Chirico both emphasizes its height
and amplifies the sense of space around it.

 The Great Tower (ill. p. 31) is another painting that operates with an impres-
sion of three-dimensionality devoid of firm foundations, so to speak. The ver-
tical stacking of the tower's architectural components once again recalls the
construction of the Mole Antonelliana, but in this case the elements are taken
from the Temple of Vesta in Rome. The composition is influenced above all by
the ideas of the Italian poet and prose-writer Giacomo Leopardi (1798–1837),
whose writings de Chirico greatly admired. Leopardi advanced a poetic theory
of the "indefinite infinite", whereby everything left hidden and only hinted at
appears more poetic and impressive than something directly portrayed: "A
building, a tower, seen in such a way that it seems to rise above a horizon
which itself cannot be seen, produces a highly effective and sublime contrast
between the finite and the indefinite." By inserting a walled piazza into the
foreground, De Chirico places the base of the tower in an indeterminate

Photograph of the arcades bordering the
Hofgarten in Munich

The Red Tower, 1913
Oil on canvas, 73.5 x 100.5 cm
Venice, Collezione Peggy Guggenheim

sphere. The purpose of the building as a whole remains veiled; it evidently
cannot be entered, it is not made for people. Its dizzying height is underlined
by the nonsensical difference in scale between the tower and the tiny, solitary
figures in the square, and by the co-existence of two vanishing points: whereas
the square is seen from above, the tower is seen from below. The shadows in
the painting have a life of their own, and no obvious light source can be iden-
tified. There is an unreal, dream-like quality to the architectural elements of
the piazza and the tower, the latter appearing strangely flat and insubstantial,
in particular in the paler areas on the right-hand side. Like all of de Chirico's
"Italian Squares", *The Great Tower* employs a perspective that no longer starts
from the world of human experience. Man has lost his secure viewpoint.

In Paris, the de Chirico family was quickly welcomed into artistic and in-
tellectual circles, thanks primarily to the numerous contacts established by
the younger of the two brothers, who now assumed the professional name of
Alberto Savinio. In 1912, thanks to the agencies of a member of the selection
committee, three of de Chirico's paintings were included in the Paris Salon
d'Automne. It was the first time his work had been seen in public. In the spring
of the following year he took part in the Salon des Indépendants. More signi-
ficant, however, was the exhibition he held in his own studio at the start of
October 1913. De Chirico showed all the Metaphysical paintings he had com-
pleted to date in their entirety – over 30 works. Amongst the small number

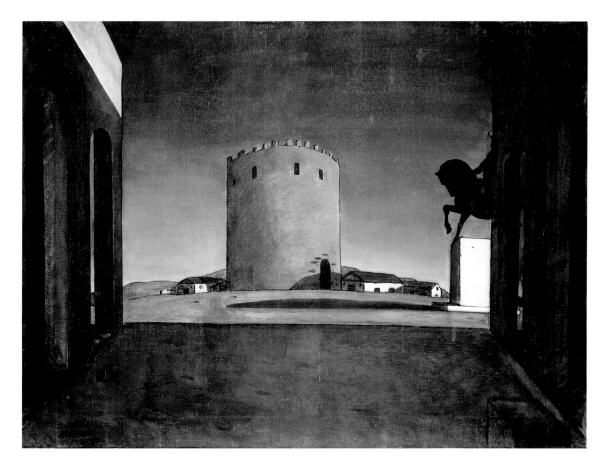

of reviews that appeared was a first appreciation by the poet Guillaume Apollinaire (1880–1918), who wrote of his "strangely metaphysical paintings" and thereby employed the term officially for the first time.

De Chirico's acquaintance with Apollinaire, who was also a close friend of Picasso, would prove the most important and fertile of his Paris period. Apollinaire was the central figure within the Parisian art scene, the core of a creative circle, whose influential writings in support of the artists of the avant-garde cannot be separated from his own poems. Many of the themes in de Chirico's paintings, Apollinaire's poems and Savinio's compositions and stage pieces document an active exchange of ideas and a pronounced degree of mutual influence – evident above all in the potent motif of the mannequin, something to which we shall return later. In 1914 Apollinaire took over the running of the magazine *Les Soirées de Paris*, around which were gathered such famous Paris artists as Pablo Picasso, Francis Picabia and Pierre Roy, as well as the de Chirico brothers. It was in this circle that Giorgio met his first dealer, Paul Guillaume, who would represent him for the next twenty years. The period of the *Soirées de Paris* up to the outbreak of World War I was a happy and productive one for de Chirico, during which many of his most important works saw the light of day.

At the end of 1913 de Chirico's painting, or rather its iconography, underwent another change. A bizarre dream led the artist to realize that his use of symbol could be significantly expanded and enriched. In de Chirico's dream, two enormous artichokes made of iron appeared to him in a piazza. The image made a profound impression upon him, and in his pictures he now started combining objects robbed of any logical mutual relationship. In his powerful and disturbing painting *The Philosopher's Conquest* (ill. p. 36), the assembled items seem to lack all connection. The composition is dominated by the objects presented in the foreground. Two artichokes are lying on a plinth near the lower edge of the painting. Beside them to the left, on a somewhat higher plinth, a white cannon with two cannon-balls projects like a phallic symbol into the pictorial space. The precisely painted clock is unusually large; its hands give the time as nearly half past one, whereas the long shadows once again suggest a sun low in the sky. The exaggerated disproportion in size between the elements of the painting has been carried to extremes. What standpoint can the viewer adopt within this picture, and how can he or she establish a relationship with the scene portrayed? The world resembles a museum full of strange objects, silent and enigmatic in their unfamiliar intensity. The towers in the background conjure the impression of the "indefinite infinite". Measured against the train puffing past it, the base of the solid red tower implies a building of enormous dimensions; the chimneystack on the left and the sailing ship evoke a sense of great distance. The architecture that bounds the right-hand edge of the canvas remains incomprehensible. Here, too, the glimpse through a window of a second tower, and the suggestion of an arcade by the patterning of light and shade, serve primarily to reinforce the impression of an indeterminate reality that mysteriously continues beyond our sight. The shadows of unseen objects fall into the picture from the right.

The programmatic title of *The Philosopher's Conquest* indicates that de Chirico was conscious of having mastered a new language with this painting. The white cannon is thereby a complex symbol that is probably based on an early Greek phallic monument in Delos. Symbol of the male principle of creativity, it can also be seen as a reference to Nietzsche's mysterious concept of the

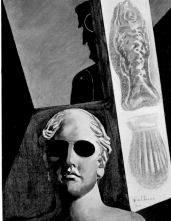

Portrait of Guillaume Apollinaire, 1914
Oil on canvas, 81.5 x 65 cm
Paris, Centre Georges Pompidou,
Musée national d'art moderne

De Chirico's homage to his poet friend shows Apollinaire in his distinctive profile view, as a shadow or a target figure. In the foreground, the classical bust wearing dark glasses refers to the blind seer of antiquity. The fish and scallop are symbolic pointers to the healing and visionary powers of the art of poetry.

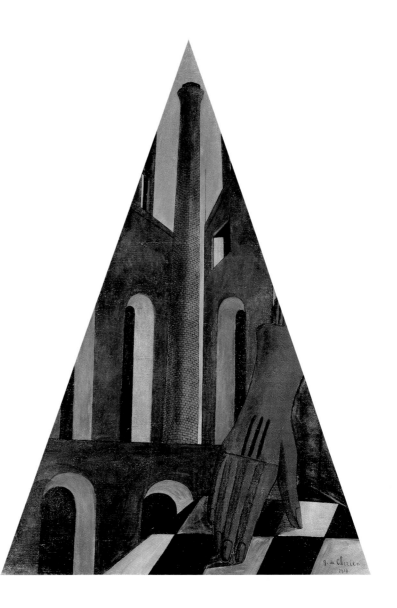

The Enigma of Fatality, 1914
Oil on canvas, 138 x 95.5 cm (triangular)
Basle, Kunstmuseum Basel,
Emanuel Hoffmann collection

The painting's unusual format makes reference
to the triangle's significance as a mystical,
magical symbol. De Chirico found support for
his attribution of symbolic value to certain geo-
metric figures in the philosophical writings of
Otto Weininger, who talked of the unsettling
effect of the triangle.

Grosser Mittag or "great noontide" – in his day, a cannon was fired daily at
midday in Paris and Rome. For Zarathustra, the "great noontide" meant high
point and turning point, the experience of eternity and the stopping of time,
a new perception of the world.

Up till now, de Chirico's Metaphysical iconography had been based on
philosophical reflections, on thoughts and feelings that, however encrypted
and enigmatic they might seem, at the end of the day nevertheless conveyed
the impression of plausible compositions. With the appearance of new signs –
fragments of reality presented within increasingly improbable settings whose
construction defies logic (cf. ill. 37) – de Chirico succeeded in translating the
experience of the non-sense of the world and the relativity of verbal definitions
into visual forms. De Chirico called his new pictorial principle the "solitude
of signs". Things are divested of their normal context, "left alone", no more

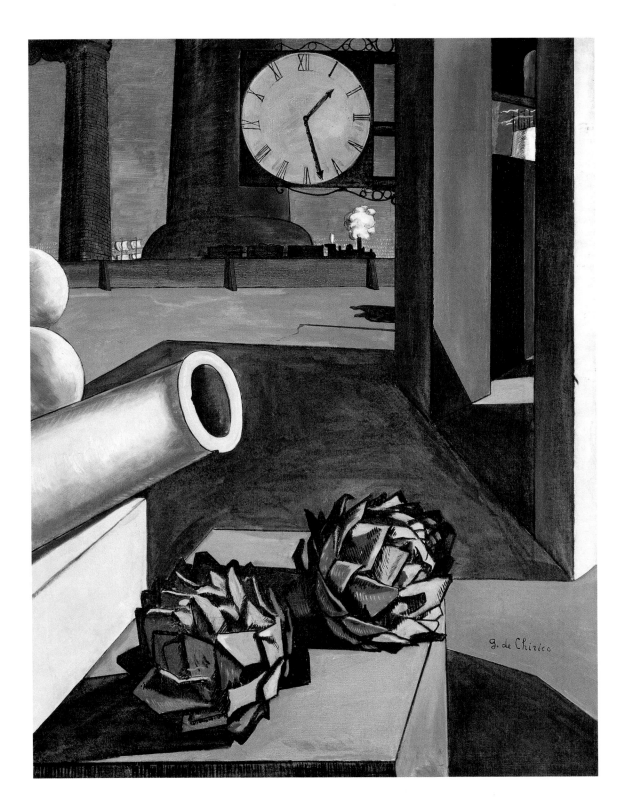

anchored to the logical systems that would commonly determine their sense and meaning. Only through the abandonment of logical principles of order, through surprising combinations and a "change of perspective" (Nietzsche) is it possible to arrive at a new, unobstructed view of the enigmatic nature of things.

In that same fertile year of 1914, the atmosphere of the metropolis also started to permeate the artist's work. From the streets around his cramped studio in Montparnasse, de Chirico could see the tall chimneystacks of the industrial districts and the new suburbs under construction. On his walks, he noticed features and objects such as goods wagons with their doors closed or half-open (cf. ills. pp. 32 and 38), which struck him as unsettling signs. "The demons of the city cleared the way for me," he noted, and in the same text described a suggestive image that found its direct expression in the painting *The Enigma of Fatality* (ill. p. 35): "The great glove of painted zinc with terrible gold fingernails, which swung back and forth over the shop door in the comfortless breeze of urban afternoons, indicated to me, with its index finger pointing down to the slabs of the pavement, the hermetic signs of a new melancholia." The motif of the glove also calls to mind Max Klinger's famous series of etchings about a lost glove, published in 1881. Klinger's glove symbolically becomes the protagonist of a narrative that relates, in strange and often unreal scenes, the hopes, yearnings, fears and visions of an unhappy love affair.

In de Chirico's œuvre the glove reappears only shortly afterwards in the famous *Song of Love* (ill. p. 41), a picture of great plasticity, as simple as it is forceful, in which the principle of the enigmatic combination of incongruous elements reaches a climax. Behind a wall in the left-hand background, the silhouette of a locomotive billowing white smoke; on the right, a building with an arcade below and open windows above; on a flat surface in the foreground, a ball stitched out of a green material. The centre of the picture is dominated by two objects of approximately the same size, both suspended from a wall resembling the coulisse of a stage set: a plaster cast based on the head of the Belvedere Apollo, and a red rubber glove. The canvas combines two strikingly different painting techniques: whereas the elements of the Metaphysical world are portrayed in highly simplified fashion, the head and the glove are rendered with extreme plasticity, as if caught in the beam of a theatre spotlight.

The glove refers to the sphere of medicine, to surgery, and above all to midwives, assistants at births in the metaphorical sense, too. Apollinaire had interpreted the figure of the midwife in this same fashion. A poem that he wrote a little later, which bears the same title as de Chirico's painting, praises love as the creative principle that underlies all life and all beauty. The metaphorical reference to a birth – the birth of a new, Metaphysical art – is linked, in de Chirico's typical automythographical manner, with memories from his own childhood, which here include the green ball and the train that ran past the end of the garden in Volos. Apollo, on the other hand, is the leader of the Muses, the god of the plastic arts; he is the guardian of the oracle at Delphi, the god of prophecy and healing, but also of death. According to Nietzsche's understanding, he symbolized the Apollonian principle of art, the world of illusion and dreams.

If the symbolism employed in *The Song of Love* is complex, it is also never fully decipherable, and it is this that makes de Chirico's poetic language so new and unique. An immediate sense of disquiet is provoked by the incomprehensible combination of the various elements, which are torn from their original

Gare Montparnasse (The Melancholy of Departure), 1914
Oil on canvas, 140 x 184.5 cm
New York, The Museum of Modern Art,
Gift of James Thrall Soby, 1077.1969

The Philosopher's Conquest, 1914
Oil on canvas, 125.1 x 99.1 cm
Chicago, IL, The Art Institute of Chicago,
Joseph Winterbotham Collection, 1939.405

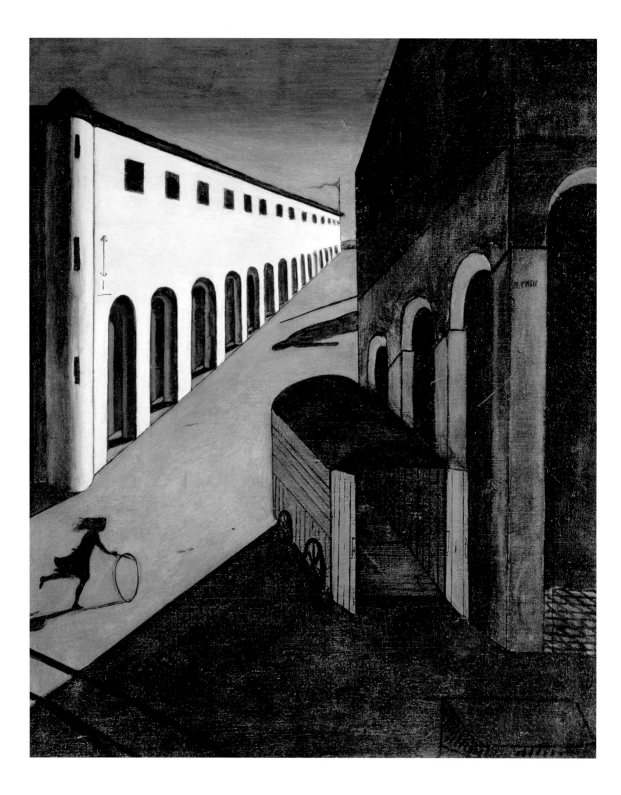

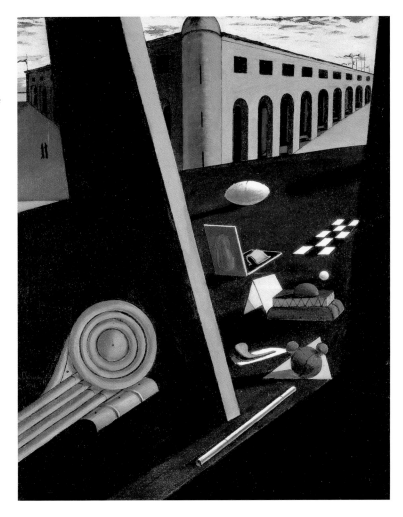

PAGE 38:
The Mystery and Melancholy of a Street, 1914
Oil on canvas, 87 x 71.5 cm
Private collection

The meeting of two shadows on a piazza:
the girl, herself a shadow, is bowling her hoop
towards the shadow cast by a statue. The picture
is divided into a world of darkness and one of
light, which fail to marry because they are con-
structed with two different vanishing points.

The Sailors' Barracks, 1914
Oil on canvas, 81.3 x 64.8 cm
West Palm Beach, FL, Norton Museum of Art,
Bequest of R. H. Norton, 53.30

PAGE 40:
The Child's Brain, 1914
Oil on canvas, 81.5 x 65 cm
Stockholm, Moderna Museet

context and exposed to the interpretations, associations, memories and feel-
ings of the viewer. The juxtaposition of different, essentially incompatible
worlds – ancient and modern, memory and present, myth and reality – is cap-
tured in a timeless moment, as it were, which recalls the moment of rapture
and absorption of which Zarathustra sings in his *Night Song*: "'Tis night: now
only do all songs of the loving ones awake. And my soul also is the song of a
loving one."

 Another very famous painting by de Chirico from 1914 is *The Child's Brain*
(ill. p. 40). It was owned by André Breton and exerted a potent influence upon
the development of Surrealist imagery. The pale, enigmatic figure with his
striking black moustache falls in line with the symbolism of the male figure
as artist-visionary and embodiment of a creative force. De Chirico's writings
allow us to identify the man as his father – who frequently appeared in his
dreams wearing a beard in the style of Napoleon III – and at the same time
as Dionysus, the god of inebriation and temptation. The yellow book – yellow
being the colour of the French edition of Nietzsche – may be understood as
the book of poetic revelation. The man's closed eyes refer to the blind seer of

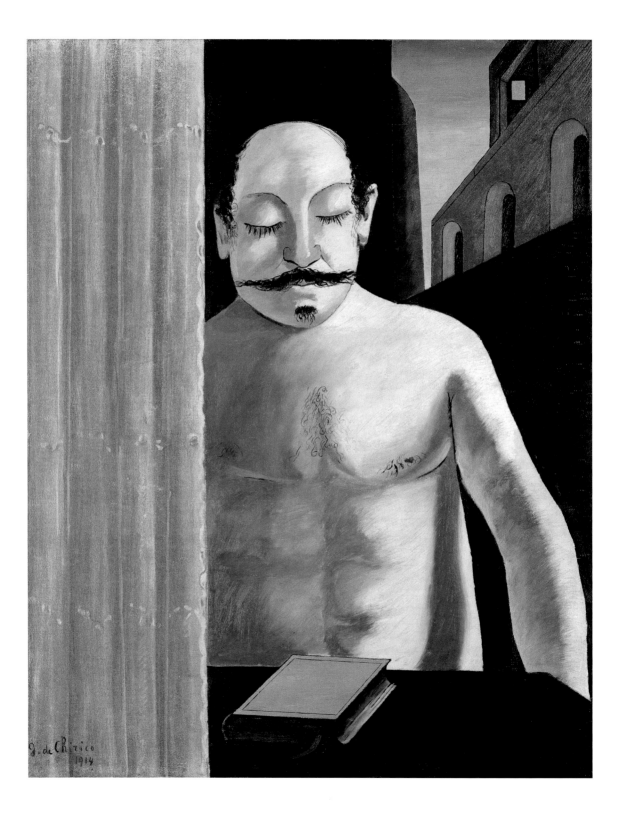

40

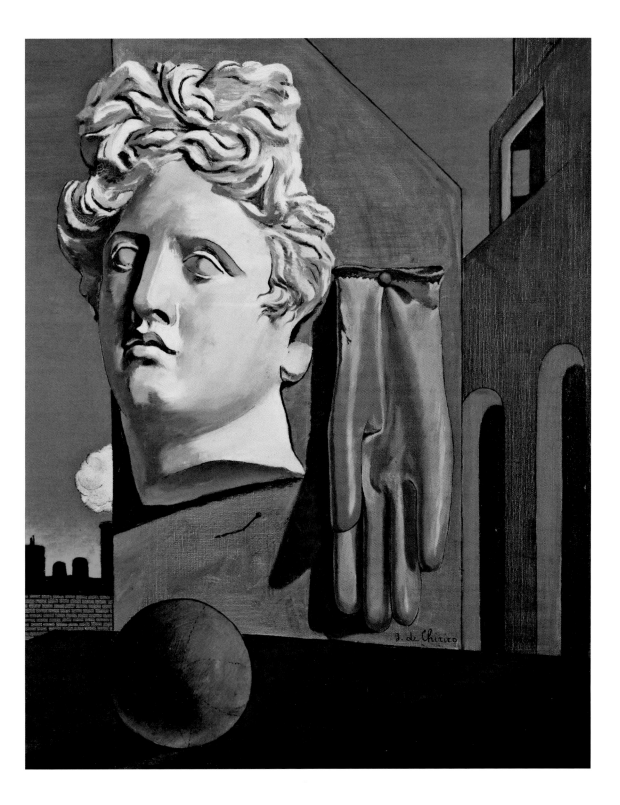

antiquity, bestowed with the gift of looking into the future and directing his gaze inwards, onto the true nature of things and not their external appearance.

The motif of closed eyes returns in another work of the same period, the famous *Portrait of Guillaume Apollinaire* (ill. p. 34). The painting resembles the interior of a magic lantern, on whose wall is projected the bust of a man seen in profile: it is Apollinaire himself, his shadow cast against a vibrant green sky like a ghost or a target figure. The painting, which Apollinaire greatly liked, was later described as "prophetic" because the poet was wounded during the First World War in precisely the spot, circled like a practice target, in de Chirico's painting. The composition is dominated by an antique-style bust, identified as blind by its dark glasses. De Chirico's homage to his poet friend celebrates poetry as an art with visionary power; the fish and scallop are ancient symbols of birth, healing and prophecy.

The target man, here portraying Apollinaire, is a forerunner of de Chirico's mannequin motif. Working closely together in the first half of 1914, Apollinaire, Savinio and de Chirico developed the motif of the faceless dummies with neither sight nor speech that would people de Chirico's works from now on (cf. ills. pp. 22, 42 and 43). They are descendants of the jointed dolls used in artists' studios and tailors' workshops in the 19th century. "Person without voice, without eyes and without face, made of pain, of passion, of joy," wrote Savinio in his 1914 *Chants de la mi-mort* (Songs of Half-death). The mannequin becomes a modern formulation of the blind seer of antiquity, a figure with visionary powers. At the same time, it offers a graphic analogy with the increasing loneliness and alienation of modern man, the dissonance of human existence.

PAGE 41:
The Song of Love, 1914
Oil on canvas, 73 x 59 cm
New York, The Museum of Modern Art,
Nelson A. Rockefeller Bequest, 950.1979

A picture like a drum beat. The bewildering juxtaposition of a rubber glove, magnified on a giant scale, with the head of the Belvedere Apollo. Objects are liberated from the contexts that normally give them meaning and assembled in surprising combinations that render them enigmatic and ambiguous.

BOTTOM LEFT:
The Seer, 1914/15
Oil on canvas, 89.6 x 70.1 cm
New York, The Museum of Modern Art,
James Thrall Soby Bequest, 01214.79

De Chirico developed the motif of the mannequin in conjunction with Apollinaire and Savinio. The human substitute without face or voice is blind like the seers of antiquity and equally gifted with the power of prophecy. The mannequin is the alter ego of the artist: the blackboard records stations along de Chirico's artistic journey.

BOTTOM RIGHT:
The Two Sisters, 1915
Oil on canvas, 55 x 46 cm
Düsseldorf, K21, Kunstsammlung Nordrhein-Westfalen

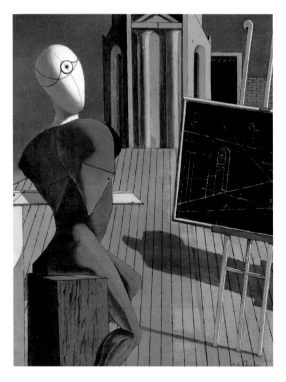

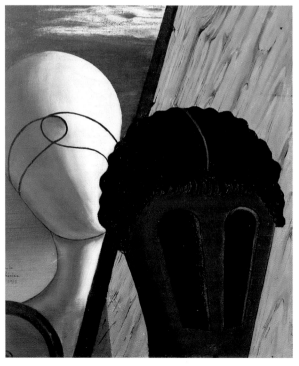

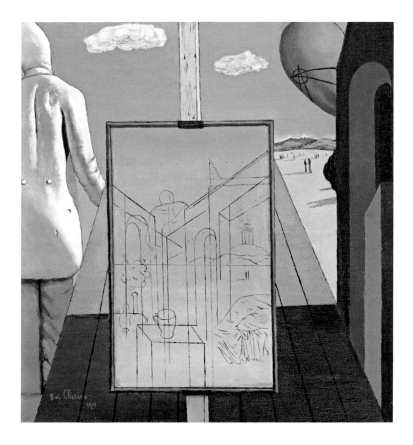

The Double Dream of Spring, 1915
Oil on canvas, 56.2 x 54.3 cm
New York, The Museum of Modern Art,
Gift of James Thrall Soby, 138.1957

The Seer (ill. p. 42) is seated on a block of wood in the foreground of a sloping square whose stage-like character is underlined by its boarded floor. The coulisse of a building in the background recalls de Chirico's first Metaphysical painting, *The Enigma of an Autumn Afternoon* (cf. ill. p.16/17). As there, so here too the drawn curtain seems to conceal a secret. The shadow of a statue falls into the picture from the right. The mannequin, propped against a large set square, contemplates with invisible eyes a blackboard bearing a perspective drawing of only superficial precision and logic. The blackboard becomes a sort of picture within a picture, recording motifs and stations along de Chirico's life: the pensive figure seen in rear view, the enigma of the arcade, Turin and the ambiguous perspective of the "Italian Squares". The seer in the shape of the faceless tailor's dummy becomes the artist's alter ego with the gift of foresight. The stage on which he makes his appearance signifies the world whose mysteries the seer has come to reveal. The artist begins to paint his own myth.

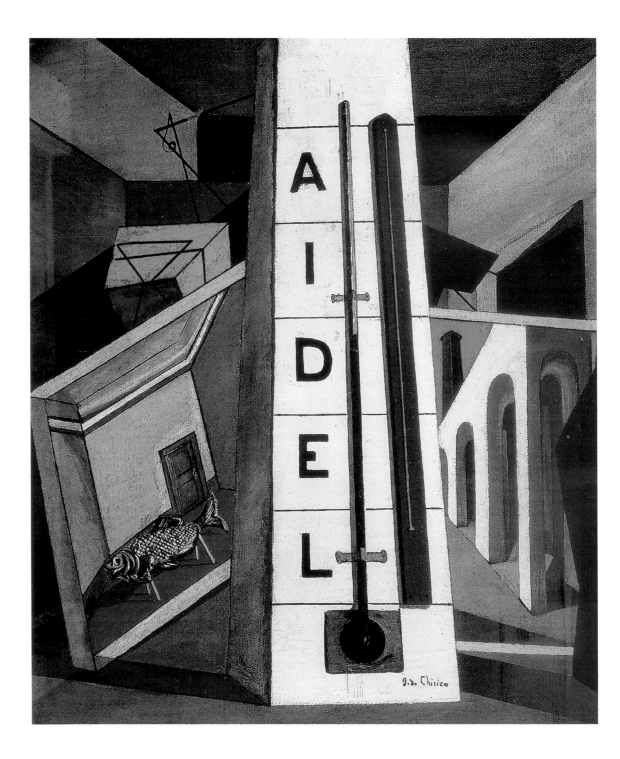

The metaphysics of everyday things

The activities of the circle of artists in Paris were abruptly interrupted by the outbreak of war. Apollinaire left the French capital as a soldier in September 1914. In May 1915 Italy declared war on Austria and offered amnesty to all deserters who presented themselves for military service without delay. De Chirico used the opportunity to escape the prison sentence still hanging over him and together with his brother reported for duty in Florence at the end of May. To their great relief, the two were not sent to the front but were given desk jobs in Ferrara. Gemma rented a flat for her sons, but for the time being kept her apartment in Paris, to which she travelled frequently during the war and where she kept in touch de Chirico's dealer, Paul Guillaume. To begin with, the brothers found their isolated situation hard to bear and strove to maintain their links with Paris through a lively exchange of letters.

As time went by, however, they began to appreciate the strange beauty of the provincial city with its self-contained atmosphere and flourishing Jewish culture. They discovered in Ferrara a source of inspiration for new subjects and motifs and began to take up their work again. De Chirico later recalled having been immediately struck by Ferrara, and in particular by the distinctive atmosphere of the shops, workshops and bakeries of the Jewish quarter, whose window displays contained a wide range of disparate objects as well as pastries and biscuits in strange forms.

De Chirico's pictures started to change. The vast, empty piazzas with their long shadows and solitary statues or mannequins gave way to cramped interiors heaped with strange objects – pennants, set squares, maps, biscuits and other pastries. It is as if de Chirico wanted to penetrate the rooms behind the dark arcades and closed shutters and discover the mysterious material world of their inhabitants. The powerful symbolism of the *Piazze d'Italia* was now toned down in favour of a more associative, almost playful poetry of everyday things. But while these accumulations of objects may not seem overbearing, they clearly reflect the artist's sense of isolation and confinement: the interiors feel claustrophobic, enigmatic and unclear, a feeling amplified in many cases by a view through a window of an indeterminate section of sky.

In a painting such as *Evangelical Still-life (I)* (ill. p. 48), sections of wood in the background recall canvas stretchers or the set squares of an engineer. Frames are incorporated like pictures within a picture. The right-hand frame

The Amusements of a Young Girl, 1915
Oil on canvas, 47.5 x 40.3 cm
New York, The Museum of Modern Art,
James Thrall Soby Bequest, 1215.79

The Dream of Tobias, 1917/1922
Oil on canvas, 58.5 x 48 cm
Private collection

The dating of this picture, too, remains the subject of debate amongst art historians.

contains a map of Istria, turned through 90 degrees anti-clockwise – in the First World War the Istrian peninsula was the subject of conflict between Italy and Austria. The shipping lanes drawn on the map are a reference to the ferries that sailed from Greece to Trieste and Venice. A striking feature, and one characteristic of many of de Chirico's Ferrara interiors, is the juxtaposition of abstract geometric constructions with objects, such as Ferrarese biscuits, painted in hyper-realistic detail: "He who bites into those fatal confections tastes eternity," wrote Savinio in a 1916 text dedicated to the city of Ferrara. The title *Evangelical Still-life* uses the word "evangelical" in its Greek sense of "good news". So too *The Jewish Angel* (ill. p. 54) makes reference to the Greek angelos, the messenger, but also to the powerful impression made upon de Chirico by the window displays of the old Jewish quarter. This Metaphysical vocabulary is to be understood less in the biblical sense than as a pointer to the rise of a new artistic language. The strange tower of Metaphysical objects in *The Jewish Angel*

The Melancholy of Departure, 1916
Oil on canvas, 51.8 x 36 cm
London, Tate Gallery

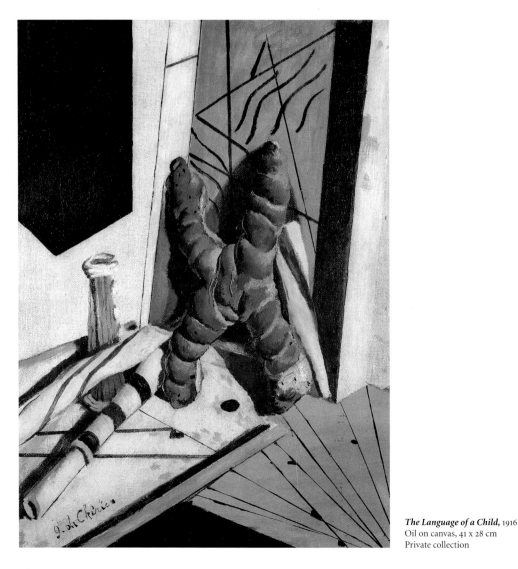

The Language of a Child, 1916
Oil on canvas, 41 x 28 cm
Private collection

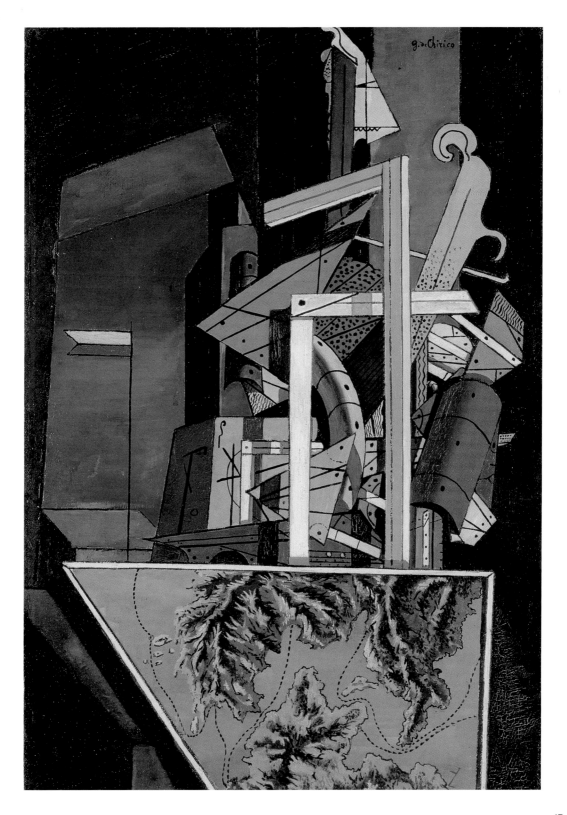

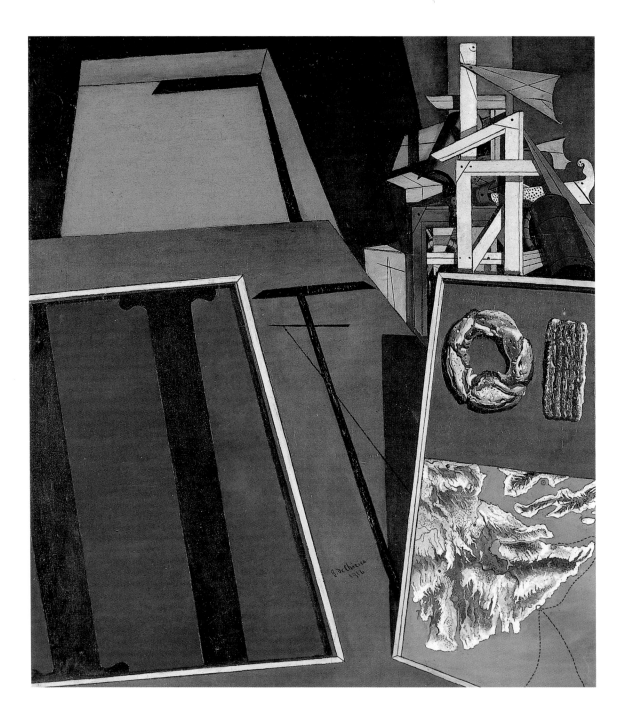

Evangelical Still-life (I), 1916
Oil on canvas, 80.5 x 71.4 cm
Osaka, Osaka Museum of Art

The "Ferrara interiors" portray incomprehensible, often claustrophobic indoor settings. They are typically characterized by the juxtaposition of abstract geometric constructions and objects painted in hyper-realistic detail, such as the pastries included here – local specialities that de Chirico used to see on display in Ferrara's bakeries.

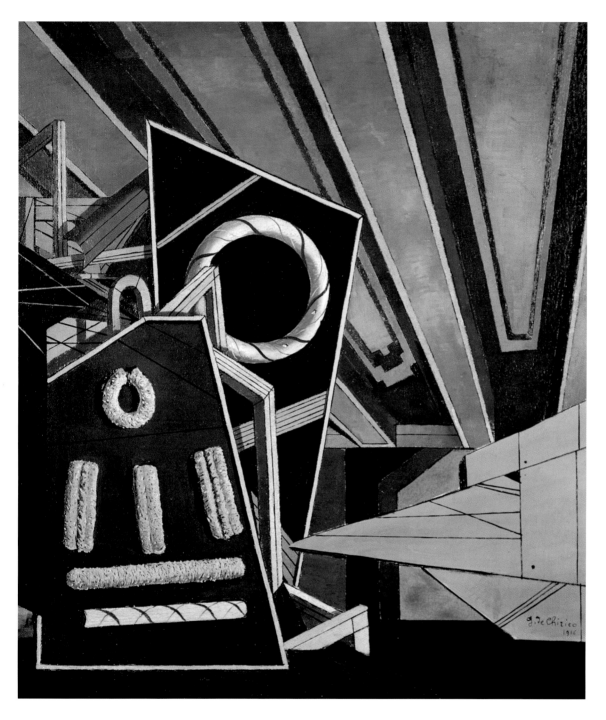

The Revolt of the Sage, 1916
Oil on canvas, 67.3 x 59 cm
London, Eric and Salome Estorick Foundation

"(My art is) a frightening cleverness, it returns
from beyond unexplored horizons to fix itself
in metaphysical eternity, in the terrible solitude
of an inexplicable lyricism: a biscuit, the corner
formed by two walls, a drawing that evokes the
nature of the idiotic and insensate world."

Giorgio de Chirico

is dominated by a sheet of paper or card with one corner folded down, on which is depicted an enormous eye, another symbol of the enigmatic and the hidden, of the secret soul of things. In a text of 1918 de Chirico wrote: "The world is full of demons – so Heraclitus of Ephesus used to say as he strolled up and down the arcades at the noontide hour pregnant with mysteries. One must discover the demon in everything. The ancient Cretans used to stamp an enormous eye in the middle of the narrow friezes that decorated their vases and pots and ran around the walls of their homes. Even the human embryo, like that of a fish, a chicken or a snake, is nothing but eye in its earliest stages. One must discover the eye in everything."

While de Chirico developed his new pictures and motifs over the course of 1916, the two brothers concentrated upon establishing new friendships in Italy, in particular with the painter Ardengo Soffici and the author Giovanni Papini, spokesman of the Italian avant-garde. Partly because they felt let down by their Paris friends, but also because they wanted to be recognized as Italian and at

Hector and Andromache, 1917
Oil on canvas, 90 x 60 cm
Private collection

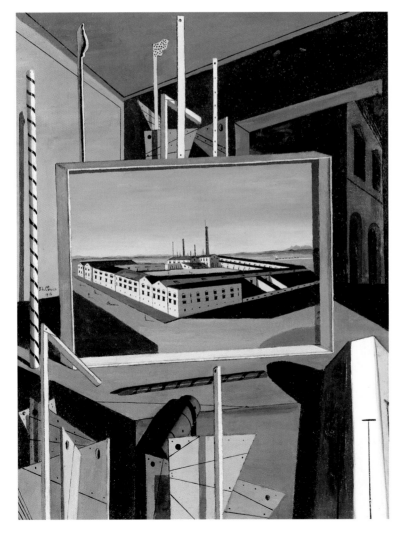

Metaphysical Interior with Large Building, 1916
Oil on canvas, 96.3 x 73.8 cm
Stuttgart, Staatsgalerie Stuttgart

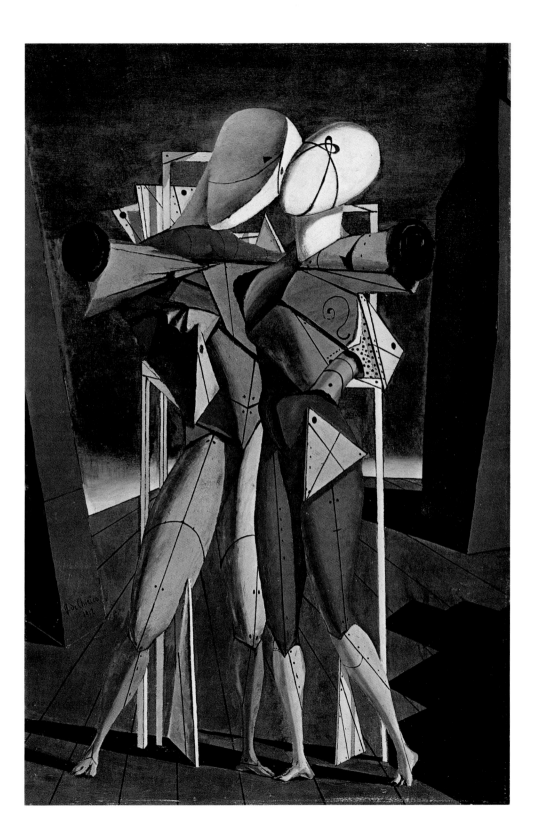

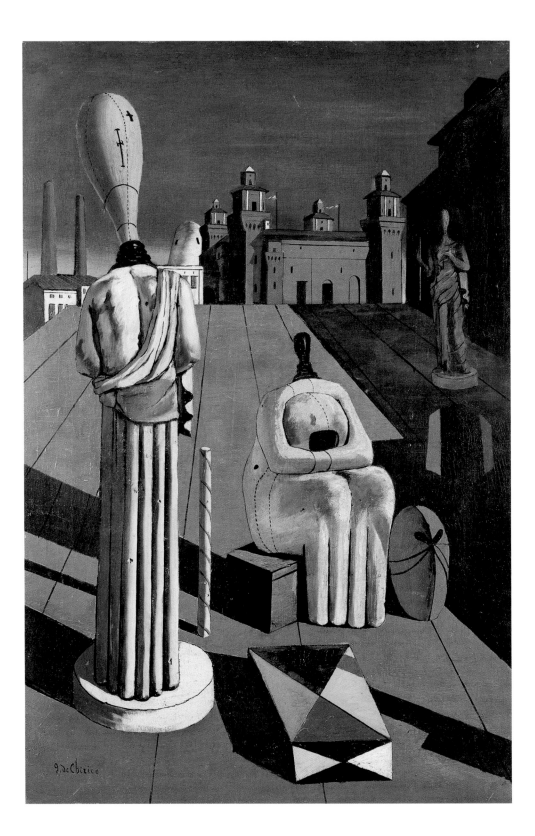

last belong to a nation, the de Chirico brothers devoted all their energies to the spread of Metaphysical art in Italy, where it was virtually unknown. Savinio assumed the role of the theoretician and published numerous articles in *La Voce* and other avant-garde journals. In Ferrara itself, the brothers struck up an acquaintance with the young painter and writer Filippo de Pisis, who not only integrated them into the cultural life of the provincial city but also showed them Ferrara's historical and artistic sights.

In spring 1917 the painter Carlo Carrà was stationed near Ferrara. Carrà had already made a name for himself a few years earlier as a Futurist, but was by this stage searching for new forms of artistic expression. A close friendship rapidly developed between Carrà and de Chirico, and when Savinio was posted to Saloniki as a translator in July that same year, de Chirico became even closer to his new companion. The exchange of ideas between the two artists was furthered by a fortuitous coincidence: both were sent for several months' convalescence to the Villa del Seminario, a psychiatric military hospital near Ferrara, where they were able to paint.

A key work from these months is *The Dream of Tobias* (ill. p. 44), whose complex meaning can be deciphered with the aid of the title. According to the apocryphal *Book of Tobit*, Tobias was instructed by an angel to place the liver of a fish on the blind eyes of his father and thereby to heal him. The fish in the shallow interior in a box on the left of the picture refers to this story and at the same time to the curative and prophetic symbolism of the fish in general, as already encountered in the *Portrait of Guillaume Apollinaire* (ill. p. 34), for example. The letters AIDEL, written beside a mercury thermometer, are a transcription of the Greek word for "invisible". The column of mercury, on the other hand, may be understood as an ironic reference to Mercury, the messenger of the gods (Mercury is his Latin name; in Greek he is Hermes). The subject of the picture is thus once again the revelation of the invisible, with the Metaphysical artist as the messenger announcing a new view of the world.

De Chirico and Carrà evidently discussed the figure of Tobias in great depth; in 1918 Carrà would write two essays on the subject. The paintings that Carrà produced during his stay at the Villa del Seminario were markedly different to his previous works. He fell entirely under the influence of de Chirico's Metaphysical imagery, to the extent of citing almost literally such characteristic elements as the fancy biscuits and the fish (cf. ill. p. 53). These few months spent together in the Villa del Seminario would later give rise to the erroneous impression that Ferrara was home to something like a "Metaphysical School", a sort of artistic movement that grew out of the collaboration of various individuals towards the end of the war. Carrà was the first to promote this idea and to claim a decisive role in the "invention" of Metaphysical painting.

In the meantime, however, the two artists maintained their friendly relations. Carrà left Ferrara in the middle of August; de Chirico remained behind and started work on a new series of pictures. He now produced some of his most celebrated and influential works, including *The Great Metaphysician* (ill. p. 55), *Hector and Andromache* (ill. p. 51) and *The Disquieting Muses* (ill. p. 52). In painterly terms, they are clearly influenced by the "Metaphysical" atmosphere of Ferrara with its reddish architecture and warm, at times unreal light. Large mannequins composed of pieces of wood, objects, set squares and fabric appear on stage-like piazzas – it seems as if the conglomerations of de Chirico's interiors have returned to the outdoors.

Carlo Carrà
The Enchanted Chamber, 1917
Oil on canvas, 65 x 52 cm
Milan, Pinacoteca di Brera

The Disquieting Muses, 1918
Oil on canvas, 97 x 66 cm
Private collection

The Muses, mythical companions of the artist, become mixtures of mannequin and statue. They appear lifeless, fragmentary, pieced together out of ancient and modern elements. In the background rises the castle built by the Este family, rulers of Ferrara, whose court was famed in the Renaissance as a centre of the arts.

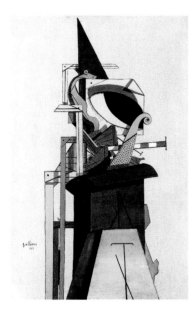

The Jewish Angel, 1916
Oil on canvas, 67.3 x 43.8 cm
New York, The Metropolitan Museum of Art,
Jacques and Natasha Gelman Collection, 1998,
1999.363.15

One of de Chirico's probably most famous paintings, *The Disquieting Muses* of 1918, cites Ferrara's most distinctive work of architecture, the massive castle built by Ferrara's ruling family, the Este, whose court established itself as a flourishing centre of the arts in the Renaissance era. The buildings of the city rise like a backcloth behind the abruptly terminating boards of the floor, which calls to mind a theatre stage or the deck of a ship. The two Muses are posted in the foreground, surrounded by their colourful, bizarre attributes. According to Greek mythology, the Muses were the daughters of Zeus and Mnemosyne, the goddess of Memory. They are the companions of the artist, inspiring every creative action, and their singing can supposedly make time stand still. Their leader is Apollo, the poser of riddles and lord of the Delphic oracle, who "neither utters not hides his meaning, but shows it by a sign," as Heraclitus wrote. De Chirico presents us with truly disquieting Muses who demonstrate nothing of the ideal of classical beauty. Half statues, half mannequins, they appear frozen, lifeless, fragmentary. The seated figure has taken off her head as if it were a mask.

De Chirico's Ferrarese friend, Filippo de Pisis, indicated that the artist was originally thinking in this picture of Vestals, the virgin priestesses who attended Vesta, the Roman goddess of the hearth and the city. The associations are far-reaching, and yet the meaning of the picture ultimately remains mysterious and cryptic. The two figures, Muses and priestesses, companions of the Metaphysical artist, are pieced together out of fragments of antiquity and the present – this gap between eras is made visible at another level by the cityscape in the background, where a factory rises beside the famous Renaissance palace. The disquieting Muses watch over the city of Ferrara and are at the same time embodiments of its enigmatic, disquieting spirit.

For all his fruitful activity during these months, de Chirico increasingly came to feel the loneliness of his situation. He kept up a lively correspondence with Carrà, who was now living in Milan, and their letters indicate that the two painters were planning to mount a sizeable exhibition in Milan and a number of other Italian cities in order to publicize Pittura Metafisica in Italy. But Carrà, an astute market strategist, instead secured himself a large one-man show in Milan at the end of 1917, which he concealed from his friend. From that time on the relationship between de Chirico and Carrà was overshadowed by the argument about who had invented Metaphysical Painting – the first of many disappointments that Giorgio de Chirico would face in Italy, and indeed elsewhere.

The Great Metaphysician, 1917
Oil on canvas, 104.5 x 69.8 cm
Private collection

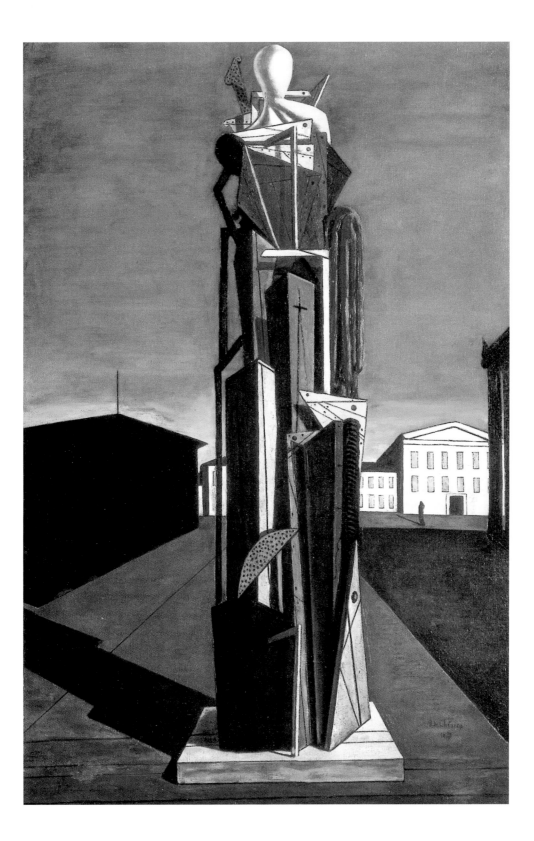

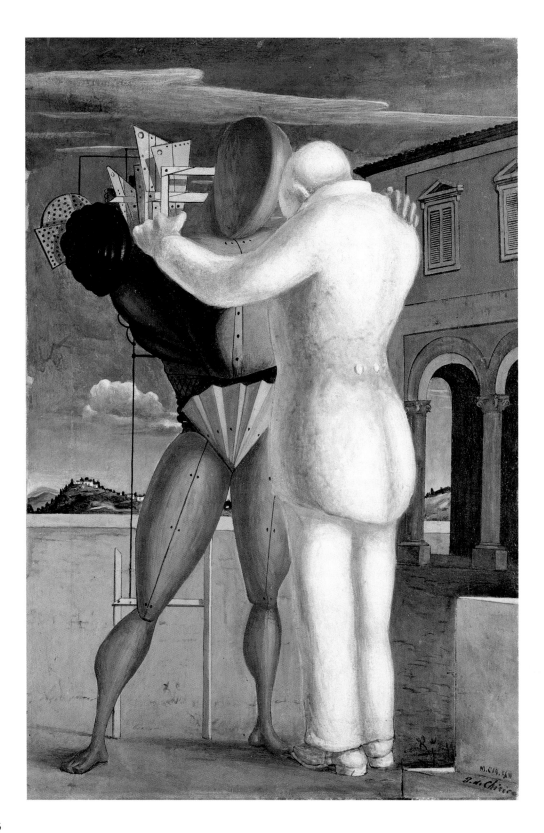

"Pictor classicus sum"

In October 1918 Alberto Savinio returned to Ferrara. A short time later Apollinaire, weakened by the wounds he had sustained in the war, fell victim to the epidemic of Spanish influenza sweeping across Europe. With his death the two brothers' hopes of further projects in Paris evaporated, and they decided to remain in Italy for the time being. At the very end of 1918 de Chirico left Ferrara and moved to Rome with his mother. In February 1919 he was given his first major one-man show in Italy, at the Casa d'Arte Bragaglia in Rome. On the occasion of this exhibition de Chirico published his famous essay "We Metaphysicians", in which he once again formulated the basic principles of his painting: "The tranquil and insensate beauty of matter is for me 'metaphysical' … (My art is) a frightening cleverness, it returns from beyond unexplored horizons to fix itself in metaphysical eternity, in the terrible solitude of an inexplicable lyricism: a biscuit, the corner formed by two walls, a drawing that evokes the nature of the idiotic and insensate world."

The success he had hoped for eluded him, however. Only one painting found a buyer, and Roberto Longhi, one of the country's most influential art critics, wrote a devastating review that would damage the image of Pittura Metafisica in Italy for decades to come. Longhi objected openly to Metaphysical art's preoccupation with the search for the hidden meaning of things rather than for stylistic innovations. With this criticism, aimed at the most important aspect of Pittura Metafisica, he effectively robbed it of its *raison d'être*.

De Chirico, for his part, began searching for new forms of expression. Around 1919 his work underwent a change of direction, which the artist once again traced to a near-mythical experience: In the Galleria Borghese in Rome, probably in front of Titian's *Sacred and Profane Love* of 1515, he was granted a "revelation of great painting". At one blow he grasped the fact that the true mystery and the true fascination were vested not in the motifs but in the technique of painting itself. On that day, so de Chirico recorded in his autobiography, the same hot south wind was blowing as had supposedly blown in Volos on the day he was born. This "revelation" in the Galleria Borghese thus represented a sort of rebirth and was followed in de Chirico's work with a new preoccupation with the biblical theme of the Return of the Prodigal Son.

The Prodigal Son (ill. p. 56) of 1922 bears witness to the phase of transition in which de Chirico found himself at the start of the 1920s. The Italian piazza is

Autoportrait, 1920
Oil on panel, 51 x 40 cm
Munich, Pinakothek der Moderne

"And what should I love if not the metaphysical essence of things?"

The Prodigal Son, 1922
Tempera on canvas, 87 x 59 cm
Milan, Civico Museo d'Arte Contemporanea

The picture marks a transitional phase in de Chirico's œuvre. The two figures still belong to the Metaphysical world. The father has got down from a plinth; the mannequin son is still entirely artificial but for the hand that he lays on his father's shoulder.

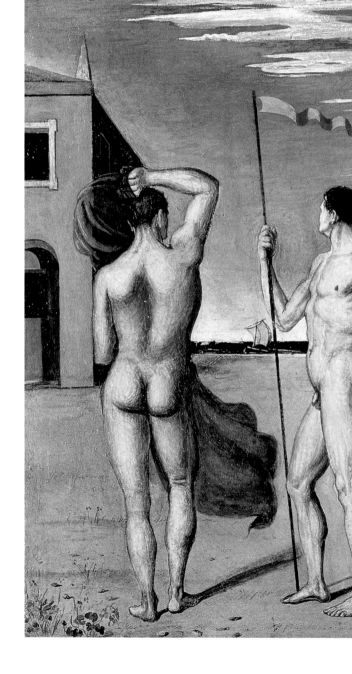

Farewell to the Departing Argonauts, c. 1920
Tempera on canvas, 54 x 73 cm
Private collection

The painting, executed in a neo-classical style, recalls the atmosphere of de Chirico's Metaphysical piazzas. Certain decisive elements have changed, however: the perspective is logical and the composition harmonious, while the statues have become people and shadows now correspond to their objects.

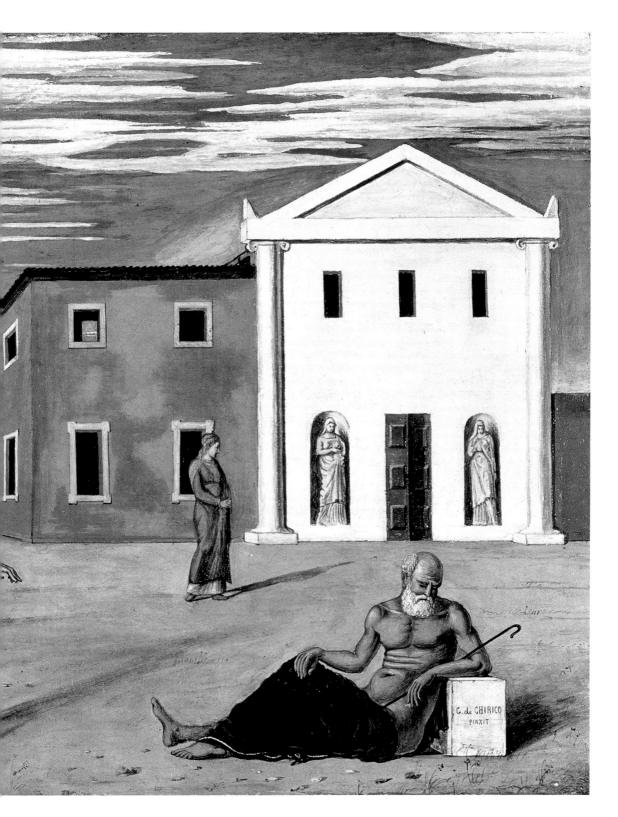

harmonious in its proportions and set against a backdrop of gentle hills. The Renaissance building on the right has lost any disquieting air. The two men meeting in the square are figures from the Metaphysical world: the father, the stone statue, has got down from his pedestal. The son, the mannequin, still needs to be supported by a scaffold of wood and wire, just as if he were taking his first steps unaided. He is still depicted as an entirely artificial dummy, with the exception of the significant, easily overlooked detail of the flesh-and-blood hand that he lays on his father's shoulder – the Metaphysician, one might conclude, returns to the arms of the Old Master. In autumn 1919 the journal *Valori Plastici* carried the celebrated article "The Return to Craftsmanship", a programmatic text in which de Chirico calls for a return to technical mastery and traditional iconography. He concludes by professing his desire to be a "classical painter": "I lay proud claim to the three words I should like to have as the seal set on each of my works: Pictor classicus sum."

Why de Chirico's painting should have undergone such an abrupt change is a question that continues to occupy art historians even today. What is the most appropriate way in which to evaluate the relationship between the early works to which de Chirico owes his international fame – the barely 150 works that he produced between 1909 and 1918 – and those of the subsequent decades? Can de Chirico's later paintings still be described as Metaphysical? Was the artist concerned solely with the search for new stylistic means, or had his philosophy

The Departure of the Adventurer, 1923
Tempera on canvas, 50.3 x 68.5 cm
Private collection

indeed fundamentally changed? Even if the artist repeatedly insisted that he remained true to his original ideas – beneath a self-portrait of 1920 (ill. p. 57), in reference to his earlier self-portrait of 1911 (cf. ill. p. 10), he wrote: "And what should I love if not the metaphysical essence of things?" – the break that occurred around 1919 is indisputably the most radical turning-point in his œuvre. That is of course not to say that de Chirico painted no more interesting pictures after 1918 – a claim that would be patently absurd. What remains unparalleled, nevertheless, is the penetrating power of his early works, which with their great simplicity have become the means of expression of the sense of fragmentation and yearning permeating modern consciousness; unparalleled, too, remains the way in which the emptiness and ambiguity of his images call forth associations within the viewer.

Having professed his allegiance to craftsmanship and tradition, de Chirico embarked on an intensive exploration of painting techniques and problems. He developed a neoclassicist style that looked back to masters of the Italian Renaissance and in consequence began to employ tempera instead of oil. Even if, in works such as *Farewell to the Departing Argonauts* (ill. p. 58/59) and *Roman Villa* (ill. p. 63), certain elements recall the iconography and atmosphere of his Metaphysical piazzas, decisive components have changed. The world has come back to life, the buildings are inhabited, perspective order has been restored, and shadows once again correspond to objects and lose their disquieting presence. People, statues, buildings and landscape blend harmoniously into an architectural whole. Despite the simplicity and linearity of the composition, the treatment of painterly details assumes greater importance. In an article in *Valori Plastici* in 1920, de Chirico discussed "the architectural principle in the painting of the past," which perceived nature and architecture alike as geometric constructions: "The perspectives of pictorial construction are full of wonder and premonition, the angles conceal mysteries." As in his Metaphysical piazzas, the artist was seeking to uncover a secret concealed behind perspective and geometry, behind the arrangement of buildings and landscape. But whereas he had previously cast order into question and abandoned perspective stability, he now embraced "solidarity and equilibrium".

In the years that followed the First World War, the journal *Valori Plastici*, in which de Chirico and Savinio published numerous programmatic texts, became the mouthpiece of a movement which emerged in many of the countries of Europe as a *rappel à l'ordre* – a "call to order" fuelled by the desire to re-impose order on a world in disarray. This same movement saw the simple, visible things of the world as offering, at least apparently, a firm hold on reality. While de Chirico pledged himself with his neoclassicist works to a "call to order" of a restorationist kind, it was the imagery of Pittura Metafisica that influenced most profoundly those interpretations of naturalism that would later be labelled Magic Realism and Neue Sachlichkeit.

In 1921 Mario Broglio, the editor of *Valori Plastici*, sent the touring exhibition "The Young Italy" to Germany. The show included 26 works by de Chirico, as well as pictures by Giorgio Morandi, Carlo Carrà and others, and made a powerful impact upon Germany's young artists. They proceeded to adopt the strict, linear perspective, the architectural approach to composition and the focus upon an often dubious world of objects and its atmosphere of loneliness and immobility.

Socially critical Neue Sachlichkeit artists such as George Grosz relieved the Metaphysical world of its timelessness and transported its motifs into a con-

Max Ernst
Aquis submersus, 1919
Oil on canvas, 54 x 43.8 cm
Frankfurt/Main, Städtische Galerie im Städelschen Kunstinstitut

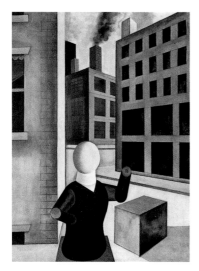

George Grosz
Untitled, 1920
Oil on canvas, 81 x 61 cm
Düsseldorf, K21, Kunstsammlung Nordrhein-
Westfalen

Roman Villa, 1922
Tempera on canvas, 76 x 51.5 cm
Private collection

temporary environment: Grosz's mannequin (ill. p. 62) of 1920 resembles a war invalid in the anonymous, dirty streets of the metropolis.

From about 1922 de Chirico's style changed again – in place of the Italian painting of the Renaissance, he turned for inspiration once more to his great predecessor Arnold Böcklin. *The Departure of the Adventurer* (ill. p. 60) is an example of this neo-Romantic style of painting, in which a soft, flickering application of paint is combined with theatrical scenes played out in a Mediterranean landscape indebted to Böcklin. Only at first sight, however, do these pictures seem works of fantasy. In reality, their architectural elements can be traced back to actual locations, subsequently transformed into imaginary spaces. Thus *The Departure of the Adventurer* blends views of Rome such as the façade of the church of Santa Maria della Pace and the street in which de Chirico had his studio, the Via degli Orti Aliberti.

In 1923 de Chirico was given his own room at the Rome Biennale, in which he showed paintings chiefly from the years 1922 and 1923. The Italian art critics attacked these post-Metaphysical works, too. It got to the point, de Chirico recalled ironically in his memoirs, where they were vying with each other to see who could write the most scathing review.

The early Twenties were unsettled years for de Chirico, characterized by searching and change. This is borne out by the fact that between 1919 and 1925 he painted more self-portraits than at any other time of his life. De Chirico interrogated the subject of himself with an almost "narcissistic obsession" (Wieland Schmied), in poses which range from pensive doubter to self-confident artist convinced of his mission. He frequently places himself beside statues of historical or mythological figures – or enters into a dialogue with himself by confronting his own statue (cf. ill. p. 64/65). De Chirico looks out of the picture with a calm, questioning air, while his petrified, other self seems to harry him, staring at him with a fixed, even merciless gaze. Vitality is confronted with rigidity, but also mortality with imperishability. It is as if immortality has already been granted him in his own lifetime.

Self-portrait with Palette of 1924 (ill. p. 66) is a programmatic statement of his new understanding of himself as a "pictor classicus" and is propelled by a visionary impetus: "Eternal fame is bestowed upon me, so that I shall be celebrated always and everywhere" runs the Latin inscription on the wall. De Chirico portrays himself at work on a painting; the grand rhetorical gesture of his outstretched arm indicates the fresh canvas and, beyond it, a section of sky suggestive of infinity. With its technically extremely differentiated use of tempera, the canvas at the same time serves to illustrate the artist's newly won conviction that "great painting", in its material substance, has the capacity "to generate a poetic momentum as the true quality of a painting" (Gerd Roos).

While de Chirico sought to establish himself more or less successfully in Italy with his new works, his Metaphysical paintings were discovered by a group of young artists in Paris and seized upon with profound admiration. The writer André Breton, the leading voice of Surrealism, was fascinated by de Chirico's enigmatic worlds from the very first time he set eyes on them, and described the artist as founder of the modern mythology. It is a well-known story that, on catching sight of *The Child's Brain* (ill. p. 40) in the window of Paul Guillaume's gallery, he leapt out of the bus he was travelling in so as to study the painting at leisure. The artist Yves Tanguy is said to have discovered de Chirico in precisely the same way just a little later. Many Surrealists described having similar key experiences and wove their myths around the early de Chirico. The Belgian

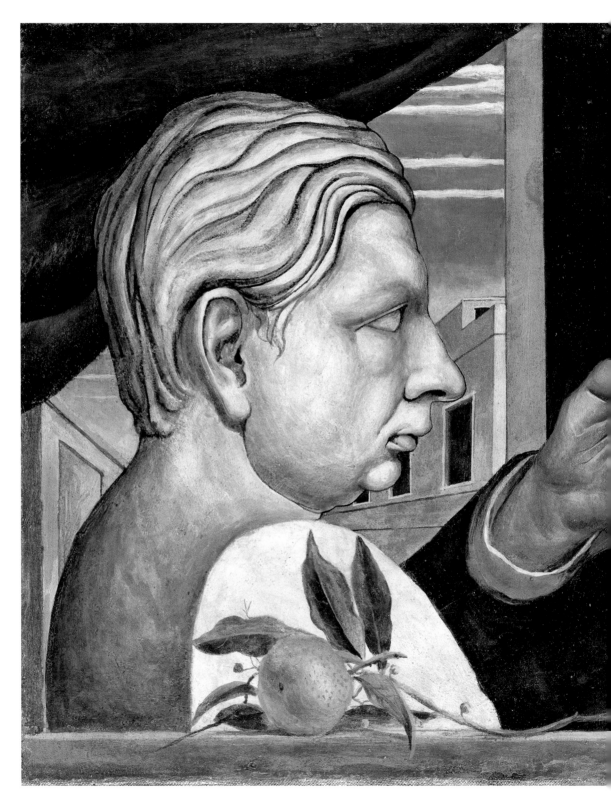

Self-portrait, c. 1922
Oil on canvas, 38.4 x 51.1 cm
Toledo, OH, Toledo Museum of Art, Purchased
with funds from the Libbey Endowment,
Gift of Edward Drummond Libbey, 1930.204

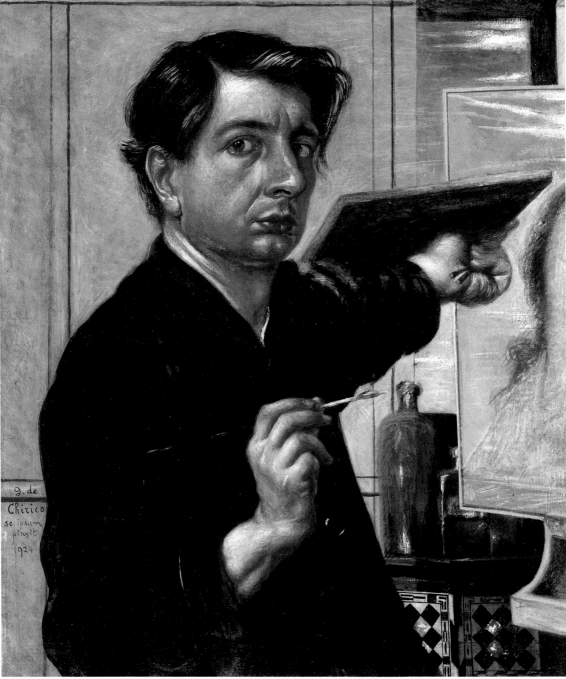

MIHI FAMA PERENNIS QUÆRITUR
IN TOTO SEMPER UT ORBE CANAR

g. de Chirico se ipsum pinxit 1924

painter René Magritte was unable to hold back his tears at the sight of a photograph of *The Song of Love* (ill. p. 41) and later wrote of the picture: "This triumphant poetry has replaced the stereotyped effect of traditional painting … It is a question of a new way of seeing, in which the viewer rediscovers his isolation and becomes aware of the silence of the world." The powerful influence that de Chirico, and in particular the motif of the mannequin, exerted on Magritte's art can be seen in *The Birth of the Idol* (ill. p. 67) from the early stages of Magritte's career. Like de Chirico, Magritte was also concerned with a philosophy-based, enigmatized poetry of the material world. He sought to lend new intensity to ordinary things dulled by the lack of heed with which they are perceived, namely by bringing them to life, deploying them within unfamiliar combinations and assigning them new functions. Table legs, for example, became chessmen and later his famous baluster-like bilboquets.

Max Ernst, himself an important contributor to the poetic imagery of Surrealism, also described his encounter with de Chirico's works – initially in the form of reproductions – as seminal. If we compare his early *Aquis submersus* (ill. p. 61) of 1919 with *The Delights of the Poet* (ill. p. 24), for example, Ernst's reference to de Chirico's *Piazze d'Italia* is clear. The symbolism of de Chirico's frozen world is subverted, however, by Max Ernst's typical use of irony. Compositional elements, magically enigmatized, take on fantastical traits: the piazza becomes a swimming pool, the moon reflected in the water bears the hands of a station clock, while, observing the scene from the background, is a smiling hermaphrodite.

De Chirico's dream-like worlds, in which reason and logic are set aside and seemingly incompatible opposites unexpectedly come face to face, must have appeared to the Surrealists to point the way forward for their own poetics, whose goal was to uncover and depict the unconscious, the hidden, the enigmatic, the irrational and the suppressed. This "total freeing of the mind" (Breton) was to be attained via a new way of thinking and seeing, which essentially followed on from de Chirico's concept of the "solitude of signs". "The chance encounter of a sewing machine and an umbrella on a dissecting table," as Max Ernst once wrote in reference to the poet Lautréamont, "is today a widely-known, almost classic example of the phenomenon whereby the juxtaposition of two seemingly foreign elements in a mutually foreign setting provokes the strongest poetic sparks …"

As fervently as the Surrealists admired and embraced the early de Chirico, so it was with equal spirit that they criticized the post-Metaphysical painter as a traitor to his own poetics and rejected his new pictures as conventional and retrograde. This parting of the ways did not happen all at once, however. At the end of 1924 de Chirico travelled to Paris and was initially accepted into the circle around Breton. The Surrealists continued to reserve judgement as far as de Chirico was concerned, and it would be a good 18 months before their abrupt and final split. The artist's official denunciation took place within the pages of *La Révolution surréaliste* in 1926, when André Breton confessed that, after five years of waiting, he now despaired of de Chirico.

René Magritte
The Birth of the Idol, 1926
Oil on canvas, 120 x 80 cm
Private collection

Self-portrait with Palette, 1924
Tempera on canvas, 76 x 61 cm
Winterthur, Kunstmuseum Winterthur

In programmatic fashion and with a grandiose gesture, de Chirico presents himself as a classical artist who has recognized that the true quality of a picture lies in its painting. An experience that he described as a "revelation of great painting" led in 1919 to a stylistic change in his work.

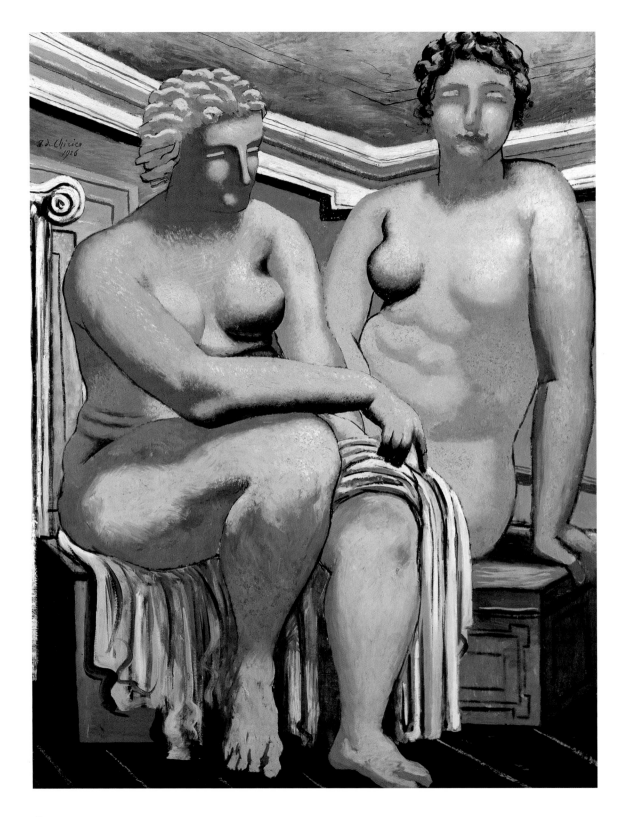

"Statues, furniture and generals"

Despite his problematic relationship with the Surrealists, who dominated the Paris art scene in the 1920s, de Chirico enjoyed astonishing success in the French capital. At the end of 1925, following a major exhibition in Léonce Rosenberg's Galerie de l'Effort Moderne, de Chirico moved back to Paris from Rome accompanied by his partner Raissa, a Russian ballerina. Savinio and his wife followed not long afterwards, and as always, both sons were accompanied by their mother Gemma.

After his disappointments in Italy, the artist now entered a productive phase. In 1927 he wrote the poetic text "Salve Lutetia", which he dedicated to the city of Paris and which testifies to a rekindled enthusiasm: "There the 'things' find their backdrop and setting. Transformed, become more mysterious and more brilliant against the great grey skies of the city that gives them the opportunity to recover themselves, they appear in a new glory. The colours become more intense, lighter and richer … even the mysterious Homer … would revive in Paris … In Paris the modern spirit assumes its most consoling form … The goddesses, returned from Greece and Babylonia, radiate in the beam of a new lighthouse." The text is symptomatic of de Chirico's works of this era, in which a spirit influenced by myth and antiquity is combined with modern elements with a directness extending to the formal level, too. The iconography that de Chirico developed in Paris in the 1920s was nourished by memories of Greece, the myth-laden land of his childhood. But although his works continued to be based on a yearning for a mythical world of antiquity, they were no longer infused with the palpable emotion of the Metaphysical spaces of his idealized Italy. Instead, they began to employ a rather more historicizing, archaeological pictorial language. Monumental female figures in antique-style settings now began to appear in his works (cf. ill. p. 68). These are undoubtedly influenced by the nudes painted a few years earlier by Pablo Picasso, who had at that time also chosen to return to classicism: inspired by representations of ancient mother goddesses, he produced his own monumental female nudes of calm and balanced proportions. By contrast, de Chirico exposes his massive female figures to a harsh lighting, which appears to issue from a neon sign and which combines in very direct fashion classical forms with a modern palette.

The horses that stand almost like chiselled sculptures on the beach (ills. pp. 72 and 73) – a subject to which he devoted so many canvases during these years that snide critics proclaimed Mr de Chirico had recently taken up horse-breeding on

Portrait of the Artist with his Brother, 1924
Tempera on canvas, 87 x 68 cm
Private collection

The intellectual affinity between the two de Chirico brothers earned them the nickname of the *Dioscuri,* a reference to the divine Castor and Pollux, sons of Leda and Zeus.

Two Seated Nudes, 1926
Oil on canvas, 115 x 88 cm
Düsseldorf, K21, Kunstsammlung Nordrhein-Westfalen, permanent loan from a private collection

an intensive scale – also draw upon a classicizing vocabulary of forms, which is frequently subverted by a highly artificial palette. In his text "Salve Lutetia", de Chirico writes about the red horse featured on posters advertising the French chocolate brand, Chocolat Paulain, and describes the sight of it as a quasi-mythical experience whose impression upon him was similar to the apparition of an antique deity.

Memory and everyday life also merge in the series of *Furniture in the Valley* and *Landscapes in a Room* (cf. ills. pp. 70 and 71), which once again take up themes of the Metaphysical period, such as the relationship between interior and exterior and the alienation of everyday objects as a consequence of their removal and isolation from their familiar context. The artist places the "intruders" on stage platforms as if on islands in the middle of a foreign environment. De Chirico described on a number of occasions how these motifs were inspired by childhood memories of the family's frequent moves in Greece and of spending the night out in the open for fear of earthquake – memories which blended with experiences of everyday life in Paris. In an article entitled "Statues, furniture and generals," which he wrote for the magazine issued by Léonce Rosenberg's gallery, the artist described the profound impression made upon him by the disconcerting appearance of pieces of furniture displayed outside shops or deposited in the street during house removals. "They appear in a new light, enveloped in a surprising loneliness: a profound intimacy forms between them; one might say that an

Furniture in a Room, 1927
Oil on canvas, 130 x 97 cm
Private collection

Furniture in the Valley, 1927
Oil on canvas, 100 x 135 cm
Private collection

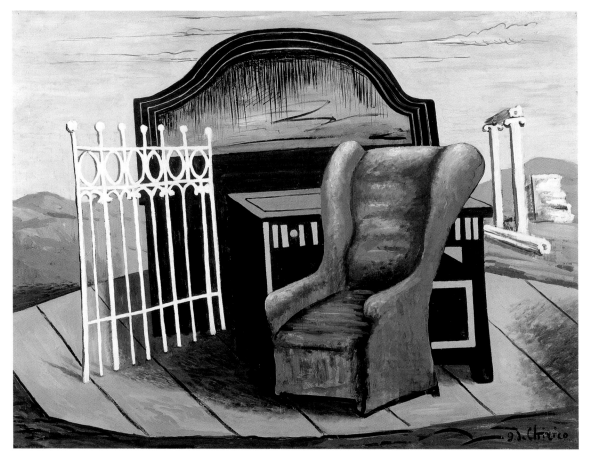

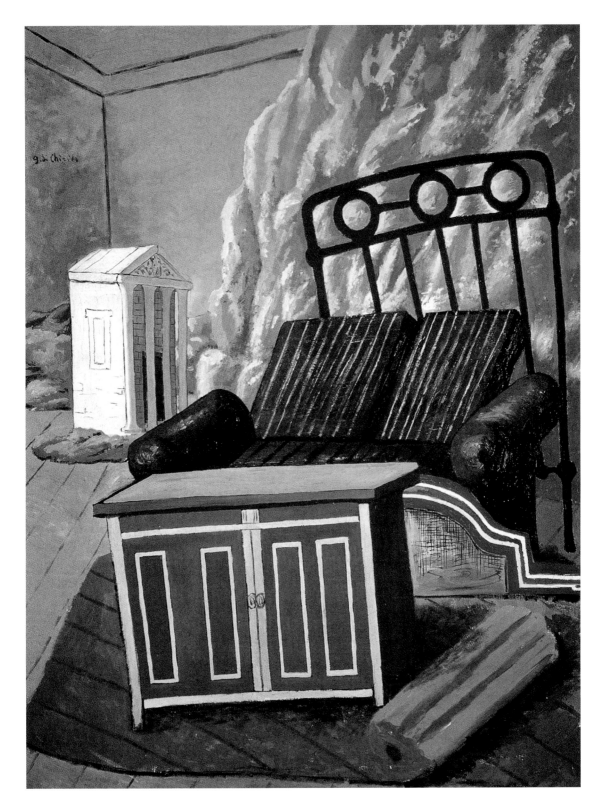

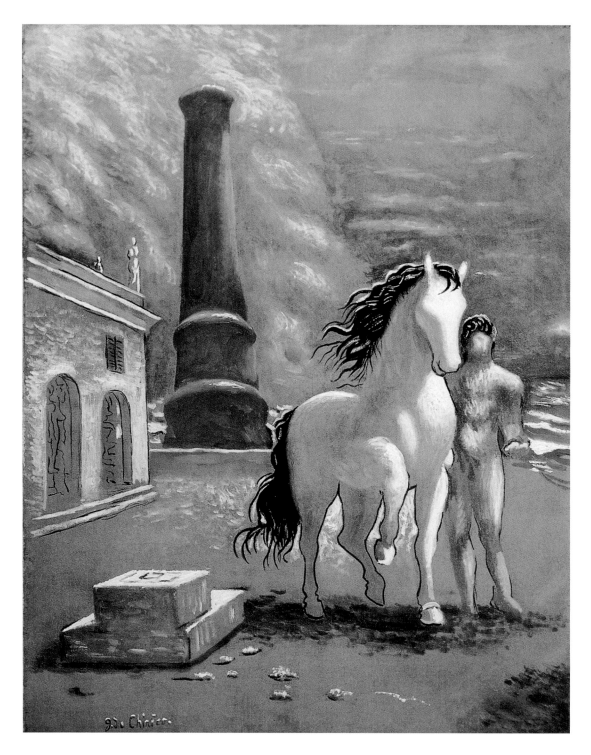

On the Shores of Thessaly, 1926
Oil on canvas, 92 x 73 cm
Private collection

Two Horses by the Sea, 1926
Oil on canvas, 92 x 73 cm
Private collection

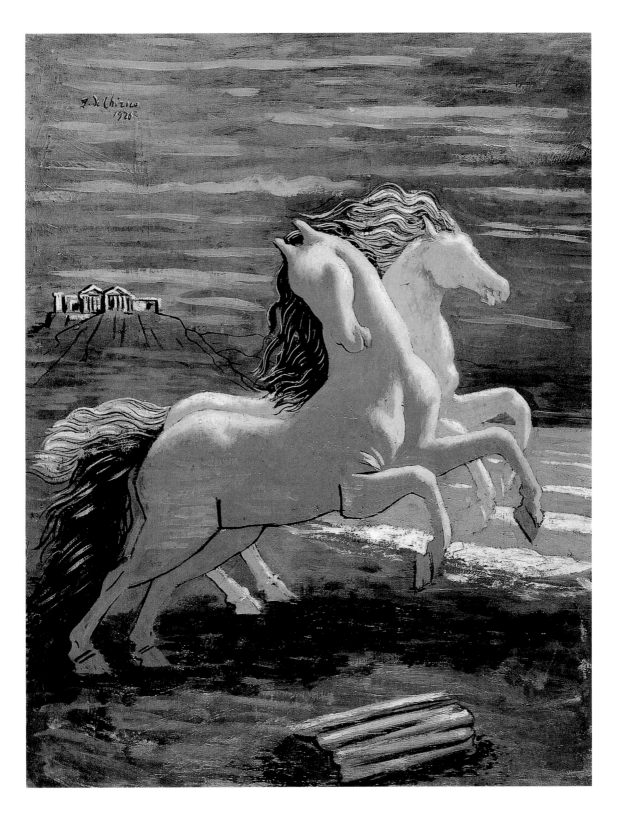

73

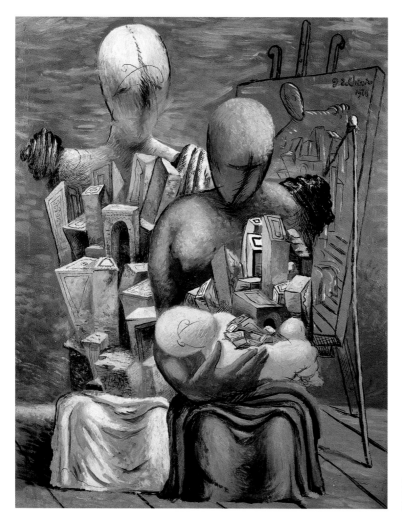

The Painter's Family, 1926
Oil on canvas, 145 x 115 cm
London, Tate Gallery

inexplicable atmosphere of happiness fills the cramped space they occupy on the pavement, amidst the seething life of the city." The poetic charge of changed places

is invoked two-fold in *Furniture in a Room* (ill. p. 71). The furniture island on its stage platform is transported back into an interior, whose nature is simultaneously cast into question by the rocks and antique fragments it contains.

An antiquity invoked by archaeological finds also characterized a new series of mannequins re-interpreting the theme of the alienation of the human figure, the petrifaction of the body and the animation of the world of concrete objects (ills. pp. 74 and 75). Part human, part doll and part statue, these hermaphrodite "archaeologists", as they are called, appear more alive, more corporeal, less isolated and alienated than the earlier mannequins. Where two or three appear together, they seem to communicate with each other; their faceless heads have an almost natural complexion. Clinging to these figures, nevertheless, is an air of tragedy. Frequently frozen in the pensive pose of the thinker and philosopher, their bodies are as heavy as lead, quite literally filled with their archaeological profession – fragments of the past, of history and of human activity.

The Poet and his Muse, c. 1925
Oil and tempera on canvas, 91 x 74 cm
Philadelphia, PA, Philadelphia Museum of Art,
The Louise and Walter Arensberg Collection, 1950

In the 1920s de Chirico painted a new series of mannequins, who appear more alive and seem to communicate with each other. Clinging to these figures, nevertheless, is an air of tragedy. Frequently frozen in the pensive pose of the thinker, their fragmentary bodies seem as heavy as lead.

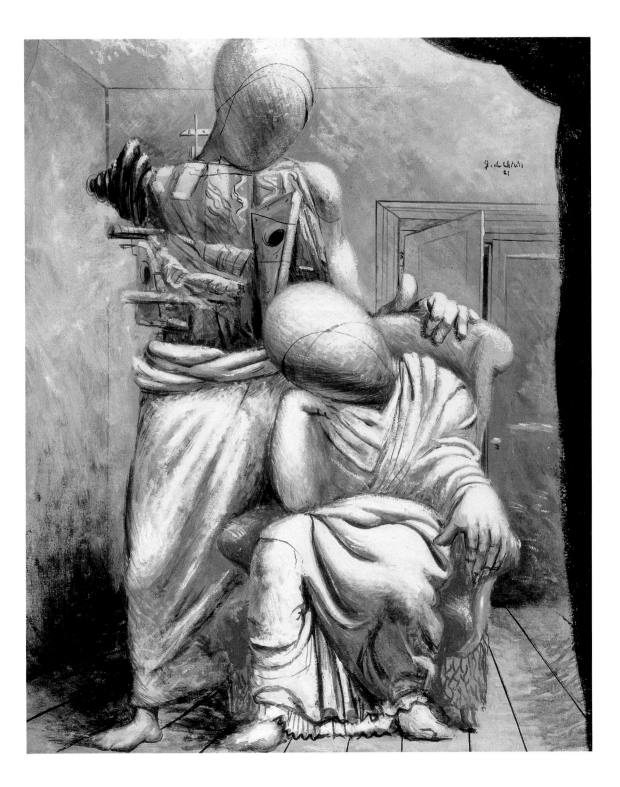

PAGE 76/77:
The Fight, 1928/29
Oil on canvas, 160 x 240 cm
Milan, Civica Galleria d'Arte Moderna

PAGE 79:
Constructors of Trophies, 1928/29
Oil on canvas, 90 x 71 cm
Milan, Civico Museo d'Arte Contemporanea

Alberto Savinio
The Enchanted Island, 1928
Oil on canvas, 114.2 x 162 cm
Cortina d'Ampezzo, Museo d'Arte Moderna
"Mario Rimoldi"

Alberto Savinio
The Magi, 1929
Oil on canvas, 89.4 x 116.5 cm
Rovereto, Museo di Arte Moderna e
Contemporanea di Trento e Rovereto

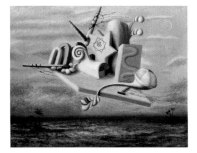

These eventful years in Paris reached their conclusion in 1929 with a commission that de Chirico carried out for Léonce Rosenberg, his eccentric dealer. Rosenberg owned a luxury apartment in Paris and decided to have each of its rooms decorated by a different painter. The artists commissioned for the project included Fernand Léger, Francis Picabia and Max Ernst as well as de Chirico's brother Savinio, who during this period also embarked on a successful career as a painter. *The Enchanted Island* (ill. p. 78) was part of his work for Léonce Rosenberg. Like de Chirico in his *Furniture in the Valley* paintings, Savinio also created compositions depicting strange objects piled up on islands or on stages in space. Around 1929 he developed the motif of flying stage platforms (cf. ill. p. 78) – he considered flying a "metaphysical human need" – heaped with colourful toys, as a metaphor for the artistic appropriation of the world. In a manner characteristic of Metaphysical poetics, Savinio combined his memories of his own childhood with the mythical childhood of humankind, with prehistory, with a "Paradise Lost" at the beginning of time, which can only be reconstructed with the help of art. Wherever employing comparable elements, however, Savinio's painting is always more playful and ironic than de Chirico's – an accurate reflection of the difference in character between the artist brothers.

In Rosenberg's magnificent home, the main salon was reserved for de Chirico. His subject matter was more or less dictated by Rosenberg, who had visualized scenes of Roman gladiator fights for his large reception hall. De Chirico created an ensemble of antique-style warrior figures who tower up into monstrous compositions of claustrophobic constriction (ill. p. 76/77). In their palette and deliberately crude painting technique they have been interpreted, probably correctly, as an ironic exaggeration of the motif. Rosenberg planned to unveil his newly decorated interiors to fashionable Paris society in a grand ceremony. The event was not a success, however, and spelled fresh disappointment for de Chirico. "The enigma of this magnificent group of warriors, of difficult to define boxers, who in one corner of the room formed a polychrome block immobile in its gestures of attack and defence, was basically only understood by himself" – thus the verdict pronounced by Hebdomeros, his alter ego and protagonist of the novel of the same name, which de Chirico published in 1929.

"I have always painted the way I wanted to"

The collapse of the Parisian art market in the wake of the Wall Street Crash of 1929 marked another major turning-point in de Chirico's artistic development. He moved city several times in the course of 1930s, always driven by the search for exhibition opportunities. His art saw abrupt changes of style and motif, inspired to a greater or lesser degree by the hope of appealing to new types of buyer. The Renoiresque style he developed around 1930 was succeeded a few years later by a type of academic realism. The model for *Bathers (with Red Drape in the Landscape)* (ill. p. 86/87), as for many subsequent paintings, was de Chirico's second wife, Isabella Packszwer, with whom he lived from 1931. In terms of earnings, this was a difficult period, and even de Chirico's return to Paris at the end of 1933 did not bring the rewards he had hoped for. In 1936 de Chirico and Isabella moved to New York for two years. The artist liked neither the city nor its atmosphere, but at least his stay brought him financial relief and a number of successful exhibitions of his current works, including the series entitled *The Mysterious Baths* (cf. ills. pp. 82 and 83).

De Chirico had started work on the so-called *Bagni misteriosi* in Paris in the spring of 1934. The series was conceived to illustrate the poem *Mythologie* by Jean Cocteau, a writer who had described de Chirico as a "painter of profane mystery". De Chirico's illustrations, accompanied by Cocteau's poem, were subsequently published as an album of ten lithographs by the Galerie des Quatre Chemins, and their highly original poetic motifs also provided the basis for a dozen paintings executed over the winter of 1934 and later (cf. ills. pp. 82, 83 and 86/87).

Running through these pictures are basins and watercourses whose surfaces resemble parquet flooring. From changing huts raised on stilts, short flights of steps lead down to the water. Men in suits stand alongside naked swimmers; in the water itself, they may be a swan or a beach ball. The scenery is rigid and bathed in a clear, strangely unreal light. As in his *Piazze d'Italia*, de Chirico once again creates a cryptic world composed of just a few elements, the sight of which is unsettling; and as in his Metaphysical paintings, this world is fed by the overlaying of different sources and memories. When the exhibition of *The Mysterious Baths* opened in the Julien Levy Gallery in New York in 1936, the critic Martha Davidson wrote a review in which she repeated the artist's own utterances: "De Chirico remembers how his father occasionally took him

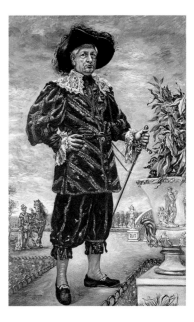

Self-portrait in Red Costume, 1959
Oil on canvas, 153 x 98 cm
Rome, Fondazione Giorgio e Isa de Chirico

Return to the Castle, 1969
Oil on canvas, 80 x 60 cm
Rome, Fondazione Giorgio e Isa de Chirico

as a child … to the public baths in Greece. The boy was deeply impressed by the difference he perceived between people dressed and undressed. They struck him as different species of animal in different spheres of existence. The clothed men towered, like overpowering and majestic statues, above the swimmers, who for their part appeared exposed and defenceless. The little bathing cabins with their cut-out windows were like masked heads watching the scene."

In addition to the memories of his own childhood, de Chirico also drew upon and combined together other sources. The swan appearing behind the bathing cabins is inspired by the illustrations in an old book that de Chirico described as having particularly impressed him as a boy. Written by Louis Figuier and published in 1872, *La terre avant la déluge* (The Antediluvian Earth) was a work of popular science whose illustrations of the natural world prior to the advent of humankind exerted a profound fascination both upon de Chirico and his brother Savinio, animating the dreams and fantasies of their childhood and resurfacing later, in particular, in Savinio's paintings. But de Chirico also drew upon Figuier's fantastical illustrations of primordial fauna: a huge plesiosaurus with a swan-like neck, soaring above a seething ocean, is transformed into the strange swan of *The Mysterious Baths*.

The Mysterious Baths, 1934/35
Oil on canvas, 79.5 x 100.3 cm
Private collection

"When I cast my mind back to my childhood, I recall that the little flights of stairs leading down from bathing cabins always agitated and dismayed me. Those few wooden steps, covered in algae and mildew – it seemed I had to climb down them, mile after mile, right into the heart of the dark ocean."

Giorgio de Chirico

Inspiration for the enigmatic iconography of *The Mysterious Baths* was also provided by Max Klinger, the Leipzig artist whom de Chirico so admired. In an essay on Klinger that he wrote in 1920, de Chirico describes in detail the etching *Chords* from the series *Brahms Fantasy* (ill. p. 84), in which – beside a storm-tossed sea and the figure of Poseidon with his mighty harp being played by mer-maids – a pianist, accompanied by a woman on a wooden platform, plays as serenely as if he were performing in a concert hall. De Chirico was fascinated above all by the paradoxical linking of a real and an unreal scene by the ingeni-ous means of set of steps beside the pianist which leads down into the sea: "When I cast my mind back to my childhood, I recall that the little flights of stairs leading down from bathing cabins always agitated and dismayed me. Those few wooden steps, covered in algae and mildew – it seemed I had to climb down them, mile after mile, right into the heart of the dark ocean. This feeling came back to me when I saw Klinger's etching."

The lyrical immobility and rigidity of the setting conveys a sense – as in the Metaphysical piazzas – of being suspended in time. The water's strange surface, which de Chirico traces back to the sight of a man reflected in a polished par-

The Mysterious Baths (II), c. 1936
Oil on canvas, 38 x 46 cm
Private collection

The Mysterious Guest, 1934
Lithograph, 28.5 x 23.5 cm
Rome, Fondazione Giorgio e Isa de Chirico

Max Klinger
Chords, in *Opus XII – Brahms Fantasy*, 1894
Etching, aquatint and mezzotint engraving
Bremen, Kunsthalle Bremen

quet floor, strengthens the impression of timelessness. These paintings may
be seen to mark the farthest point reached by de Chirico in his search for for-
mal innovation and new motifs; the works that came after were in other "neo"
styles or were repetitions of his own compositions and subjects.

At the end of 1939, after de Chirico and his wife had settled back in Milan,
his painting underwent yet another change of direction. The canvases of the
next decades would be characterized by a neo-Baroque style inspired by Peter
Paul Rubens (cf. ill. p. 86/87). In 1942 the artist showed these new works in public
for the first time in his own room at the Venice Biennale. With this return to the
Baroque, the glittering era of "great painting", de Chirico – now styling himself
pictor optimus, "best painter" – wanted to hold up to his colleagues the mirror
of tradition. His sense of mission culminated in the large number of self-por-
traits in historical dress that he executed – not without irony – during these years
(cf. ill. p. 81).

The Apparition of the Swan, 1934
Lithograph, 21.5 x 18.6 cm
Rome, Fondazione Giorgio e Isa de Chirico

There were many tragic aspects to the final decades of de Chirico's life. Despite numerous exhibitions, the artist felt himself increasingly misunderstood, isolated and criticized. The painter who had provided such decisive stimuli for early Modernism became ever more radical in his rejection of what he considered to be a short-lived and market-driven modern art. From 1950 onwards he organized "anti-Biennale" exhibitions in Venice and polemicized against the "dictatorship" of Modernism in a series of essays. Added to this was his bitterness over the never-ending series of scandals and court cases surrounding forgeries of his work, in particular of his Metaphysical paintings. What was put down in de Chirico's own lifetime to failing powers of judgement or the excessive paranoia of an ageing artist has since been proven: de Chirico is probably the most forged artist of the 20th century. A forgery ring that was finally broken up in Italy in the late Seventies had already brought thousands of fakes into circulation and was preparing many more. What made it so easy to sell forgeries

Bathers (with Red Drape in the Landscape), 1945
Oil on canvas, 109 x 140 cm
Rome, Fondazione Giorgio e Isa de Chirico

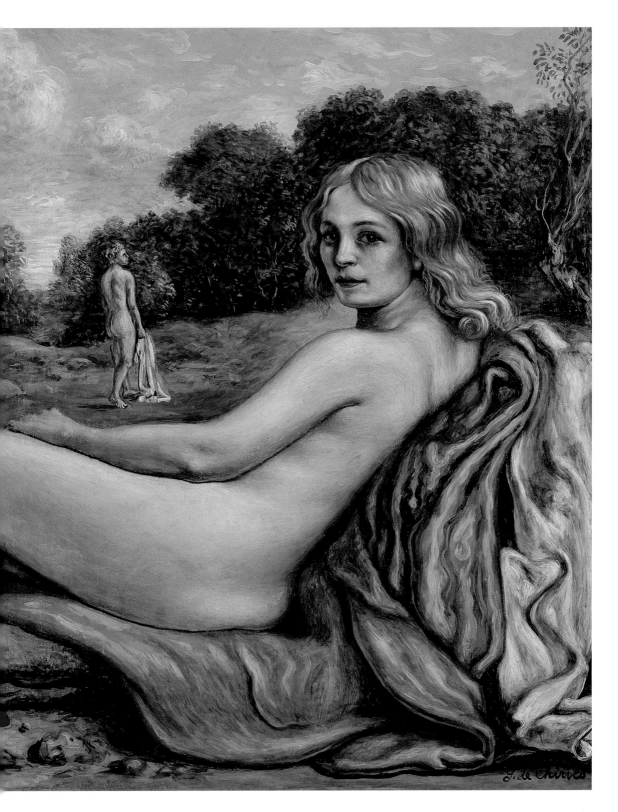

Metaphysical Interior with Extinguished Sun,
1971
Oil on canvas, 80 x 60 cm
Rome, Fondazione Giorgio e Isa de Chirico

Calligrammes 230, 1930
Lithograph, 15.5 x 15.9 cm
Geneva, Musée d'art et d'histoire, Cabinet des Estampes

One of de Chirico's illustrations to Apollinaire's *Calligrammes*, published by Gallimard, Paris, 1930

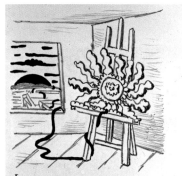

*Le régiment arrive
Le village est presque endormi dans la lumière parfumée
Un prêtre a le casque en tête
La bouteille champenoise est-elle ou non une artillerie*

was de Chirico's own habit of executing several copies or variations of his famous compositions and motifs. As early as the 1920s, at the request of Paul Eluard and others, he began painting different versions of his Metaphysical pictures.

From 1967 de Chirico referred back to the inventions of his early years in his so-called neo-Metaphysical paintings. These are by no means mere repetitions of earlier works, but are compositions with their own originality. They process and expand upon the themes of the *Piazze d'Italia* and the *Mysterious Baths*, and above all upon the motifs with which de Chirico had illustrated *Calligrammes*, the collection of poems by his friend Apollinaire, more than 20 years earlier (ill. p. 88). Stars, moons and suns, tied together by electric cable, which go out in the sky and light up again in the room (ill. p. 89), continue in a different way de Chirico's poetics of places that have been changed, of a familiar order that has been upset. The use of colour is also different. In place of the predominantly subdued palette of the Metaphysical period, the painter now deploys bright pastel shades. A number of formal innovations also appear, old motifs in new clothes, such as the Böcklinesque knight who rides as a jagged-edged figure in deepest black across the bridge towards his castle (ill. p. 80).

Despite the distorted, shadowy outline of the horse and rider, this neo-Metaphysical world is less unsettling, more playful and more light-hearted. The sense of inner constriction that characterized the paintings of the Metaphysical period is entirely absent from these compositions. A certain distancing from his earlier works is tangible in his new treatment of old motifs.

The various guises that de Chirico had assumed over the course of his long life led one last time back to Odysseus, the mythical traveller with whom the artist had identified right at the start of his artistic journey. *The Return of Ulysses* (ill. p. 90/91) does not, however, show an artist-philosopher pondering the mysteries of the world and his own existence, nor the triumphant return of a legendary hero. Ulysses is rowing his boat across the waves of a pool of water in a furnished room. The reproduction of a Metaphysical painting on the wall and the view of a Greek temple through the window complete the scene. The traveller, one might conclude, has survived the adventures of his journey. Or were they actually no more than the dreams of a stay-at-home? Has the homecomer ever been away? Or have Ulysses' great discoveries and his fateful journey into the unknown taken place only in his head? Once again de Chirico, now with gentle irony, leaves us uncertain of the answer.

The Return of Ulysses, 1968
Oil on canvas, 60 x 80 cm
Rome, Fondazione Giorgio e Isa de Chirico

Giorgio de Chirico 1888–1978
Chronology

1888 De Chirico is born on 10 July in the Thessalian port of Volos in Greece, to parents of Italian origin. His father Evaristo, an engineer, is in charge of the construction of Thessaly's rail network. His mother Gemma Cervetto, an opera singer, comes from a family of possibly Genoese extraction. Three years later a brother is born, Andrea Alberto, who later takes the professional name of Alberto Savinio.

1900 Takes classes in painting and drawing at the Athens Polytechnic.

1906 Following the unexpected death of their father in May 1905, the two sons move with their mother to Munich. Giorgio enrols at the Royal Academy of Fine Arts. During his next two years in Munich, he absorbs the influence of the pictorial imagery of Arnold Böcklin and Max Klinger.

1909/10 Moves to Milan to join his mother and brother. Suffers from poor health. Stimulated by his reading of Nietzsche and Schopenhauer, begins to formulate the principles of Metaphysical poetics.

De Chirico paints pictures in the style of Böcklin. He experiences his famous "revelation" in the Piazza Santa Croce in Florence, which results in his first Metaphysical painting, *The Enigma of an Autumn Afternoon*.

1911 After spending a few months in Florence, the de Chirico family moves to Paris.

1912 In March de Chirico is recalled to Italy for military service and posted to Turin. He deserts after ten days. The city of Turin, so closely bound up with Nietzsche's destiny, leaves a profound impression upon his work. Embarks upon his famous series of *Piazze d'Italia* ("Italian Squares"). Exhibits three pictures at the Paris Salon d'Automne, the first time his work has been shown in public.

1913 Exhibits over 30 works in his studio. Friendship with the poet Guillaume Apollinaire, who writes of his "strangely metaphysical paintings".

1914 Exhibits at the Salon des Indépendants in Paris and Galerie Giroux in Brussels. Within the circle of artists constellated around the magazine *Les Soirées de Paris*, he meets his first dealer, Paul Guillaume. Paints major works such as *Portrait of Guillaume Apollinaire* and *The Song of Love*.

1915 The brothers present themselves for military duty in Italy and are given

desk jobs in Ferrara. They make the acquaintance of the painter Filippo de Pisis. De Chirico starts painting *Metaphysical Interiors*.

1917 Represented at the first Dada show in Zurich. The painter Carlo Carrà is posted to Ferrara. De Chirico and Carrà spend several months convalescing in a psychiatric military hospital, where they are able to work. De Chirico paints major works such as *The Great Metaphysician* and *The Disquieting Muses*. His relationship with Carrà is increasingly overshadowed by the dispute over the "invention" of Metaphysical painting.

1919 First major solo exhibition in Italy at the Casa d'Arte Bragaglia in Rome. The exhibition is not a success. In summer he experiences a "revelation of great painting", prompting the first major change of direction in his work. Develops a neo-classicist and neo-Romantic style. Lives in Milan and Florence.

1921 First exhibition of his new works in Milan, again to scathing reviews. Takes part in the influential exhibition "The Young Italy" in Germany.

1924 Makes a trip to Paris and is accepted into the circle of Surrealists around

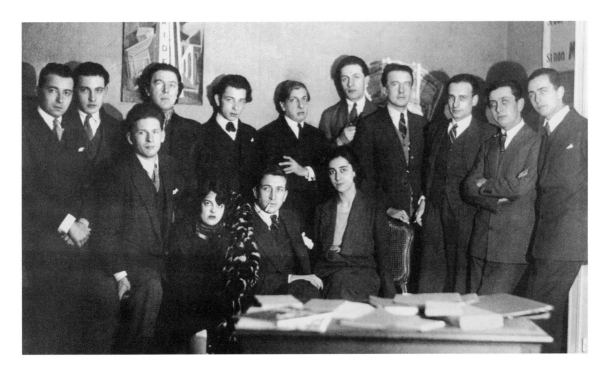

André Breton. The famous group photograph taken by Man Ray appears a few weeks later on the front cover of the first issue of *La Révolution surréaliste*.

1925 Works for Luigi Pirandello's *Teatro d'Arte* in Rome and meets his future wife, Raissa. After a major one-man show at Léonce Rosenberg's Galerie de l'Effort Moderne in the summer, he moves back to Paris at the end of the year.

1927 Exhibitions with Paul Guillaume and Jeanne Bucher. Publication of the monograph by Roger Vitrac and other writings on de Chirico. New series of *Archaeologists*, *Furniture in the Valley* and *Horses on the Shore*. His relationship with the Surrealists becomes increasingly problematic.

1929 Designs stage sets and costumes for Serge Diaghilev's ballet *Le Bal*.

Decorates Rosenberg's apartment with the *Gladiator* series. Publishes the novel *Hebdomeros*.

1930 Takes part in numerous exhibitions. Meets his second wife, Isabella Packszwer. Publication of Apollinaire's *Calligrammes* accompanied by over 60 lithographs by de Chirico.

1931 Moves to Italy. Exhibits in various European cities. Starts painting in a Renoiresque style.

1934 Returns to Paris. Develops the series *The Mysterious Baths* to illustrate Jean Cocteau's poem *Mythologie*.

1936 Moves to New York.

1938 Returns to Italy and emigrates briefly to Paris, but upon the outbreak of war moves back to Italy and settles in Milan.

1939 His œuvre undergoes a change of direction, as he embraces a neo-Baroque style indebted to Rubens. Starts polemicizing against modern art with increasing vehemence. Major exhibition devoted solely to Pittura Metafisica at the Galerie Il Milione in Milan.

1942 Presents his neo-Baroque works in his own room at the Venice Biennale.

1945 Settles permanently in Rome. Publishes his memoirs, the novel *Une aventure de M. Dudron* (English title *Monsieur Dudron's Adventure*) and the collection of essays *Commedia dell'arte moderna*.

1946 Forgeries of his work appear on the international art market with increasing frequency. De Chirico takes up his fight against forgeries and launches various legal actions, including taking the Biennale to court in 1948. Buys a luxury apartment on Piazza di Spagna.

1949 Major exhibition to mark his election as an honorary member of the Royal Society of British Artists. In 1950, as part of his campaign against "modernism", he organizes the first of his Anti-Biennales in Venice. Intensive work for the theatre.

1953 Isabella Packszwer, writing under the pseudonym Isabella Far, publishes the first monograph on her husband's neo-Baroque work. The following year de Chirico organizes the last of his Anti-Biennales.

1955 Exhibition of Metaphysical paintings in the Museum of Modern Art, New York. James Thrall Soby publishes his standard work on de Chirico (1st edition 1941). Exhibitions in Italy and abroad. At the Biennale in 1956, de Chirico again shows his neo-Baroque work.

1968 First exhibition of his neo-Metaphysical works in Milan.

1970 First retrospective at the Palazzo Reale in Milan and at the Kestner-Gesellschaft in Hanover.

1971 Claudio Bruni Sakraischik embarks on the publication of the catalogue raisonnée of de Chirico's works, of which eight volumes have appeared to date.

1973 Wieland Schmied publishes the first anthology of de Chirico's writings. Exhibitions and theatre projects take de Chirico to Athens and New York, amongst other places.

1974 De Chirico is elected to the French Académie des Beaux-Arts and has a major exhibition in Paris the following year.

1978 De Chirico dies in Rome on 20 November, a few months after his 90th birthday and is buried in Sant'Andrea delle Fratte. His tomb is today housed in San Francesco a Ripa in Rome.

TOP LEFT:
De Chirico and Isabella in front of *Bathers on the Beach*, 1936

TOP RIGHT:
At the ceremony at the Académie des Beaux-Arts, 1974

BOTTOM:
Giorgio de Chirico in his apartment on Piazza di Spagna, Rome, c. 1975

Selected bibliography

Writings by Giorgio de Chirico

Giorgio de Chirico, *Memorie della mia vita,* Milan 1962

Giorgio de Chirico, *Hebdomeros*, París 1929; published in English as: *Hebdomeros: With Monsieur Dudron's Adventure and Other Metaphysical Writings,* Cambridge (MA)1993

The Memoirs of Giorgio De Chirico, translated from the Italian and with an introduction by Margaret Crosland, Cambridge (MA) 1994

Giorgio de Chirico, *Il meccanismo del pensiero. Critica, polemica, autobiografia 1911-1943*, edited by Maurizio Fagiolo, Torino 1985

Quotations are taken from de Chirico's *Memorie della mia vita* and *Il meccanismo del pensiero.*

Standard works on Giorgio de Chirico

Paolo Baldacci, *De Chirico: The Metaphysical Period, 1888–1919,* Boston (MA) 1998

Maurizio Fagiolo dell'Arco and Paolo Baldacci, *Giorgio de Chirico, Parigi 1924-1929 – dalla nascita del Surrealismo al crollo di Wall Street,* Milan 1982

Maurizio Fagiolo dell'Arco, *De Chirico – gli anni trenta,* Milan 1995

Wieland Schmied, *Giorgio De Chirico: The Endless Journey,* Munich, Berlin, London, New York 2002

Exhibition catalogues

Giorgio De Chirico and the Myth of Ariadne, edited by Michael R. Taylor, Philadelphia Museum of Art, Chicago (IL) 2002/2003

Die andere Moderne – de Chirico / Savinio, edited by Paolo Baldacci and Wieland Schmied, Kunstsammlung Nordrhein-Westfalen, Düsseldorf; Städtische Galerie im Lenbachhaus, Munich 2001/2002

Giorgio de Chirico – Der Metaphysiker, edited by William Rubin, Wieland Schmied and Jean-Clair, Haus der Kunst, Munich; Centre Georges Pompidou, Paris 1982

Detailed information about the Fondazione Giorgio e Isa de Chirico in Rome and its research activities can be found on the internet at www. fondazionedechirico.it as well as in the journal *Metafisica – Quaderni della Fondazione.*

Photo Credits